BRITAIN IN OLD PHOTOGRAPHS

THE ROYAL ARSENAL, WOOLWICH

ROY MASTERS

edited by ALAN TURNER

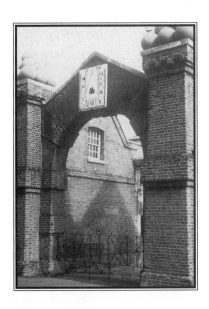

ALAN SUTTON PUBLISHING LIMITED

Alan Sutton Publishing Limited
Phoenix Mill · Far Thrupp · Stroud
Gloucestershire · GL5 2BU

First published 1995

Copyright © Vera Masters, 1995

*Title-page photograph: the arch and sundial;
the latter dates from 1764. (AT)*

British Library Cataloguing in Publication Data.
A catalogue record for this book is available from
the British Library.

ISBN 0–7509–0894–7

Typeset in 9/10 Sabon.
Typesetting and origination by
Alan Sutton Publishing Limited.
Printed in Great Britain by
Hartnolls, Bodmin, Cornwall.

This book is dedicated to the fond memory of my
father, George Finch Masters OBE, MIMechE, CM,
and to my mother, Frances Daisy Masters. My father
was able to rise from an Apprentice Engineer, at the
age of fourteen, to become Director of Ordnance
Factories at the Ministry of Supply during the Second
World War. In addition, my parents contributed five
sons to the war effort.

Contents

Foreword

When Roy Masters returned to the Royal Arsenal in 1989, it was to retrace the steps of his boyhood days when, in 1921, at the age of six, he moved with his family to live in official quarters in Avenue 'H'. His father, G.F. Masters OBE, MIMechE, CM, had then just been promoted to Manager of the Royal Gun and Carriage Factories having been born in the Arsenal at No. 3 Avenue 'H' in 1877, one of thirteen children. George Masters subsequently enjoyed a most successful career, being Superintendent of the Royal Gun and Carriage Factories from 1936 to 1942 and Director of Royal Ordnance Factories from 1942 to 1947. In addition to Roy's father, five uncles were also employed in senior positions in the Arsenal during the period 1921 to 1940.

In 1989 it was my pleasure to accompany Roy on his first visit to the Arsenal after so many years, and I was immediately struck by his great enthusiasm and affection for what he called 'The Shop' and his knowledge of the buildings where he played as a child. This visit triggered Roy's desire to obtain as much information as possible about the Arsenal and he began the extensive researches which have resulted in this book. His enthusiasm was put to good use in giving talks to local groups and he became a well-known and popular speaker. He very generously donated any contributions from such talks to the Royal Arsenal Woolwich Historical Society.

It was always Roy's great ambition to document the history and buildings of the Royal Arsenal and to reveal 'The Secret City' to a much wider audience. Sadly, Roy did not live to see his dream come true; he passed away on 22 January 1995.

My thanks are due to Roy's widow Vera who has made much material available in order that this book may be published.

Alan Turner
Chairman, Royal Arsenal Woolwich Historical Society

Introduction

How little the average person knows about the Royal Arsenal, Woolwich, home to the most famous of all Royal Ordnance Factories. For over 300 years it has been a secret walled city, self-sufficient and subject to the highest level of security. As it grew and developed our sinews and arms of war, it became the main source of the implements of war required by our fighting services. Even those weapons not actually manufactured in the Arsenal were often tested and approved within its boundaries. It has enabled us to protect our tiny island over and over again against the much greater powers of other European countries. Equally, it enabled us slowly but surely to extend our trading routes, developing links with our allies and building up the greatest colonial empire that the world has ever seen.

The Royal Arsenal, Woolwich, really began over 300 years ago, when the area was used as a store in support of the Greenwich, Deptford and Woolwich dockyards. Records show that an Ordnance Store was in existence as early as 1565, supplying guns, cannon balls and gun carriages to the ships under construction. On the area known as 'The Warren', Proof Butts were built and cannons were tested by General Blake and his Ordnance officers. In 1667 Prince Rupert was instructed to prepare a gun-battery on The Warren riverside, facing north in order to provide a defence against the Dutch Fleet approaching London.

Situated between the gunwharf and The Warren, was a manor house known as Tower House, and later to be known as Tower Place. The Crown had by 1670 decided to expand its operations on the site and, in 1671, purchased the house and 31 acres of land from Sir William Pritchard for £2,957 and the gunwharf. The spacious grounds were soon to be covered with cannon-balls, cannons and gun-carriages destined for the ships being built or repaired in the Royal Dockyards. Soon the Great Barn at Greenwich was re-erected in the Warren grounds and, in 1696, two Royal Laboratories (East and West Pavilions) were built to manufacture gunpowder, ammunition and pyrotechnics. A Comptroller of Fireworks was appointed in 1696/7 to preside over the munitions activities and, by then, the Carriage Department was in existence. At that time, the Crown did not manufacture its own cannon, and purchased or captured weapons were fitted on to new or repaired carriages. There are firm references to the Carriage Department of 1680, and the old and new carriage-yards appear on plans of the Warren compiled by Gen. Borgard, the first Commandant at Woolwich.

Up to 1716 the Crown had always preferred that the founding of brass and iron guns should be carried out by private enterprise, and much of this work

was done by a foundry at Moorfields in the City of London. In that year, a serious accident occurred during the remelting of captured French cannon, resulting in the death of seventeen persons including the Foundry owner. Following this disaster, the Crown decided to exercise more control over gunfounding and gave approval for a Royal Brass Foundry to be built in The Warren. This was completed in 1717 to a design by Sir John Vanbrugh, and a young Swiss, Andrew Schalch, was appointed as Master Founder. At the same time other important developments were taking place in this area, including the formation of the first two companies of Royal Artillery. The 'Great Pile' buildings were erected between 1717 and 1720, surrounding Artificer's Court and Basin Court and being used as storehouses and workshops. In 1764 a sundial was erected over the main entrance and led to the name 'Dial Square' being given to this part of The Warren. It is today a very pleasant enclosed Green which may be viewed from Beresford Square. The Royal Brass Foundry was extensively renovated during the 1970s and is the Royal Arsenal's only Grade 1 listed building. It is said to be one of the finest remaining cannon foundries in Europe. It is currently occupied by the National Maritime Museum and used as an archival store.

In 1741 part of Tower Place was taken over for use as a Military Academy, for the instruction of young officers belonging to the Royal Artillery and Royal Engineers. The Academy remained at Woolwich until 1806 when the Royal Military Academy opened on Woolwich Common. It was not until 1805, following a visit by George III, that at his suggestion The Warren was officially named the 'Royal Arsenal'. During the period 1776–1856 much new building work was carried out, mostly by convict labour from the prison hulks in the Thames. Their accomplishments included such labour-intensive projects as digging the canal and lock gates, and building the Arsenal wall, the 'T' Pier and the Iron Pier.

No iron guns were made in the Royal Arsenal until 1854/5, when the Armstrong Gun Factory was built to boost production for the Crimean War. The many wars and Army campaigns all meant expansion of the Arsenal's facilities. It began with The Warren of approximately 42 acres and this increased eventually to almost 1,300 acres.

The many workers employed in the Arsenal mostly entered by the Beresford Gate, erected in 1829 in honour of Lord Beresford, Master General of Ordnance. The Arsenal wall, surrounding the 'Secret City', was completed to Plumstead railway station in 1857, at which time about ten thousand men and boys were employed in the war effort associated with the Crimean War. During the First World War this figure rose to eighty thousand, a large proportion of whom were women, because men were absent on active service. During the Second World War this figure was much reduced, owing to the need to disperse the armament factories as a protection against air attacks.

From 1950 the Arsenal began visibly to shrink as defence work was transferred to private industry and the MoD began to release parts of the Arsenal site for public use. It started in 1956 with the sale of 118 acres for a trading estate, and this was followed by the development of Thamesmead new town.

In retrospect, by 1918 the Arsenal had become the largest and most concentrated armament manufacturing centre in the United Kingdom and I was lucky enough to see this monster in its prime. I was nearly six years old when I went to live in the official quarters in Avenue 'H' of the Arsenal where my father had just been promoted to Manager of the Royal Gun and Carriages Factories – the date was 1921! The Arsenal was then beginning to shed some of the extra 'fat' acquired during the First World War but all the trappings were there to be seen. I saw it all fall away until 1930 when it was only a shadow of its former self. Then, under the shadow of Adolf Hitler, I saw it flex its muscles and expand again.

In spite of the Royal Arsenal's impressive record, few people today are fully aware of its history, and it is probable that the name is more often associated with the football team or railway station. Documenting the enormous history of the establishment has been done most comprehensively by Brig. O.F.G. Hogg in his book *The Royal Arsenal: Its Background, Origin and Subsequent History*. He was, when I lived there, the Military Secretary to the Ordnance Select Committee and also a resident in Dial Square. The book is, alas, now out of print but may be seen at most larger libraries.

Maps show that, at one time, the Arsenal stretched from the Woolwich Free Ferry to Crossness Point on the south bank of the Thames. On the inside curve of this crescent-shaped boundary, the wall stretched for 4½ miles from the ferry, past Plumstead railway station, along the south-east London sewage outfall to Abbey Wood and thence via Berber to Crossness Point Belvedere, crossing the marshes of Plumstead, Erith and Belvedere. The northern boundary was a river front of just over 3 miles and included four major piers, a tremendous complex! Official records show that over 1,100 different buildings, offices, shops, sheds, huts, and so on, existed in the Royal Arsenal, covering aspects of research, design, production and the testing of weapons for our Armed Forces. To house the enormous number of workers employed by this enterprise, it was necessary for accommodation in the surrounding areas to be greatly expanded.

The following statistics give some idea of the vastness of the production undertaking during the First World War:

New Guns	4,326
Repaired Guns	5,434
New Gun-carriages	2,165
Repaired Gun-carriages	1,217
Empty Shells	5,847,400
Filled Shells	19,910,300
Filled Cartridges	46,121,200
Empty Fuses	3,368,200
Filled Fuses	59,251,400
New Trench Mortars	899
Repaired Trench Mortars	68
Mortar Bombs	352,100
Small Arms Ammunition	1,718,813,298

My father, G.F. Masters OBE, MIMechE, CM was Superintendent of the Royal Gun and Carriage Factories from 1936 until 1942, when, at the request of Winston Churchill, he moved to the Ministry of Supply at Shell Mex House. He then assumed responsibility for the eight Royal Ordnance factories which, by then, had been dispersed throughout the United Kingdom.

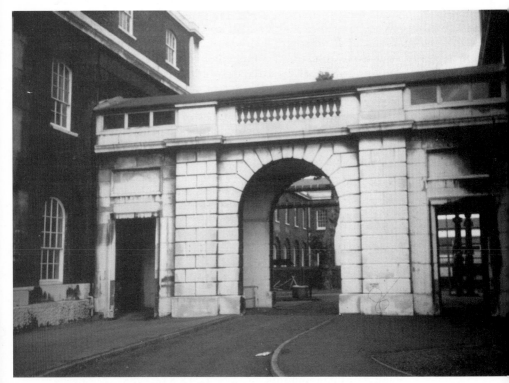

Grand Archway entrance to the Ordnance Store.

THE EARLY DAYS

To meet the many requirements of the Dockyards to equip ships and the Armed Forces, large quantities of rope were required. In order to meet these demands, rope-making factories were erected at Portsmouth, Woolwich and Chatham. Those at Portsmouth and Chatham still exist, but not as commercial units. The Chatham facility has, however, been restored to full working order and may be viewed as part of the Chatham Historic Dockyard complex. The Woolwich 'Ropeyard' (p. 13), built between 1573 and 1576, was separated from the Warren fence by a road, known as Ropeyard Rails (which has now been renamed Warren Lane), running along the outside of the Royal Arsenal. The Warren Lane Gate is, at present, the only means of access to the site.

A Gunwharf was established at Woolwich early in the sixteenth century and was a small area between the Thames and Woolwich Street with a river frontage of 265 feet. In 1586 guns captured by Sir Francis Drake in West Indies were brought to the store. Space was very limited in the Royal Dockyard and, when ships were being constructed or repaired, materials had to be stored and safeguarded. The area around Tower Place soon became such a repository and, in December 1682, it was ordered 'that the number of 1,000 cannon and 10,000 demi-cannon round shot be taken out of the unserviceable bins upon Tower Wharf, on each side of Traitor's Gate, and sent down to Woolwich'. At about this time, the proof of ordnance was transferred from Moorfields to Woolwich and private founders were allowed to prove their guns at their own expense. An early view of the Warren is shown on p. 14.

Tower Place (pp. 14 and 15) was purchased by the Crown in 1671 together with 31 acres of land which had, originally, belonged to two religious houses before Henry VIII dispossessed them; St Mary Overy at Southwark and St Augustine, Canterbury. When the mansion was built is not known, but by its architectural style it must have been of recent construction when, on 10 March 1538, Thomas Smythe sold it with other lands in Woolwich and Plumstead to Sir Martin Bowes, Goldsmith, Lord Mayor of London, 1545–6. In 1719 the whole house was remodelled and reconstructed by Sir John Vanbrugh. He added a new façade, shorter than the original front so that the tower, which had been integral with the old mansion, became detached as can be seen in the

painting of the Royal Military Academy (RMA) by Paul Sandby (engraved by M.A. Rooker) on p. 16. Following this reconstruction, it was instituted by royal warrants into a royal military academy for instructing members of the military branch of ordnance in mathematics and other skills. The room to the south was used for this purpose, that to the north being used as a Board Room for the Officers of the Ordnance. When the RMA moved to their new home on Woolwich Common in 1806, Tower Place became the Pattern Room for the Royal Laboratory. After the Second World War the building became the Chief Inspector of Armaments' Mess. Latterly it was known as the Officers' Mess and used by senior staff working in the Arsenal until closure of the site (pp. 16–17). Of particular interest is the fine clock and wind-direction indicator by John Bennett, a watch and clock maker of Greenwich and Blackheath (p. 17).

The oldest buildings on the Royal Arsenal site are the East and West Royal Laboratory Pavilions dating from 1696 (p. 18). The original Royal Laboratories were in Greenwich and Eltham Palaces and it is not until the end of the seventeenth century that it is mentioned in connection with The Warren. By 1676 various hutments had sprung up under the watchful eye of the Ordnance Storekeeper, and it was then decided to build a Royal Laboratory to manufacture ammunition, fuses and gunpowder. The square formed around the original pavilions was finally roofed over between 1750 and 1800 to form Building A15, a very large machine-shop which was believed to be the largest in Europe (pp. 18–19). The buildings are currently in a very dilapidated condition although the royal cypher of William III is still clearly visible on the West Pavilion.

Although there are eighteen listed buildings on the site, only one is Grade I, this being the Royal Brass Foundry of 1717 (pp. 20–1). Following completion of the foundry, the 'Great Pile of Buildings' was established in the Dial Square area, to a design attributed to Sir John Vanbrugh, including the Storehouse and Workshop (p. 22) which survives today. The name Dial Square originates from the sundial which was erected over the main entrance to this building in 1764.

Up to 1717 The Royal Carriage Department carried out the function of building, repairing and modifying carriages for cannons in Carriage Square in The Warren at Woolwich. This was an open space with some sheds just to the east of the Tower Place building. In 1717 the New Wheeler's Shed was constructed and became Building C13, the main centre for carriage work. The building, which blocked off the eastern end of Avenue 'H', was used during the Boer War as a concert hall for band concerts and dances, during one of which my father met my mother. It was a huge, open barn of a place with a stage and gallery around three sides. Originally, it had been a drill-shed for the Royal Artillery in which to develop drills for new artillery equipment as part of the Artillery College of the Military College of Science. In the 1930s it was a storehouse for ceremonial guns and gun-carriages used for State funerals and special occasions. The building, which was demolished in the 1970s when the Plumstead Road was widened, is shown on p. 22, just before the area was cleared.

Building A86/87/95 (p. 23) was built to house the nucleus of the Royal Artillery when it was first formed in the Warren in 1741, and remained their accommodation until 1796. From that date, it was the main accommodation

for retired officers of the Royal Artillery, Royal Engineers and Royal Army Ordnance Corps, many of whom had served as Inspectors of Artillery, etc. The Master Founder, Andrew Schalch, also lived there during his tenure of office. Whilst I lived in Avenue 'H', Brig. O.F.G. Hogg, the author of the definitive history of the Royal Arsenal, lived at no. 4 and a Lt.-Col. Drummond of the RAOC lived at no. 3. Their families had the use of a deep sunken garden at the rear of the house and the very pleasant Green in Dial Square where their children used to play.

The Warren water-front at that time can be seen in an old print (p. 23), dating from 1739. Some of the activities of the establishment can be judged from a local newspaper dated 20 June 1740:

Complaint having been made to the Lords of the Admiralty that the gunpowder used by the three men-of-war when they took the *Princessa* was weaker than the powder taken in the said ship, in the proportion of seven to twelve, it was thought proper to make a publick tryal. In order thereto, some gunpowder was taken out of each of the above four ships, put into four boxes at Portsmouth, which were sealed up by officers of the Navy and Ordnance, and sent to town and this day try'd at Woolwich before the D. of Montagu, Master-General of the Ordnance, Sir Charles Wager, Lord Vere Beauclerk, General Borgard, some captains of men-of-war, etc., in three diverse ways. 1. By raising a weight of 20lbs. 7oz. with 2 drams of powder. 2. By firing a twelve-pounder shot out of a $5^2/_3$-inch mortar with a quarter of an ounce of powder. 3. By firing a half-pound shot out of a swivel gun with 2 drams of powder. In the first experiment the English powder raised the weight from 4 inches to 6 and some tenths, and the Spanish no higher than 1 inch and 9 tenths. In proving the swivel gun, the English powder threw the ball $15^3/_7$ feet at an elevation of 61 degrees, and the Spanish had not strength enough to throw it out of the gun; and the trial by the mortar turned out equally in favour of the English powder.

A good idea of the appearance of the Warren in 1750 can be obtained from the print on p. 24.

As mentioned earlier, I had the good fortune to spend a happy childhood in Avenue 'H' with my family. This area was originally the part of Woolwich Green acquired by the Ordnance Board to build houses for the Officer-Cadets and staff of the Royal Military Academy, which were known as the Officer Cadet Quarters (p. 24). It was, therefore, a little 'up-market', comprising a beautiful road of trees, two large green swards for the use of the cadets and very nice accommodation for the cadets and their teachers. The latter were accommodated in a central block in order that they could keep an eye on the behaviour of their pupils. The attractive lawns were used by the cadets for their sports, exercises, drills, trenching, revetting, gun-drills, etc. Later, such buildings as the surgery, mortuary, hospital and apprentices' club were added in the same architectural style. Following the move of the academy to new accommodation on Woolwich Common, the vacant buildings were then used as Quarters to house senior staff who were needed to be 'on-call' by the factory (p. 25). Although only separated

from the busy Plumstead Road by a few yards and the 20 ft high Arsenal wall, our family spent a rural-style life in very pleasant surroundings (pp. 25–6). We did, however, have a factory clock in the centre of Avenue 'H' to remind us that the 'Shop' was not far away (p. 27). During the 1970s, Avenue 'H' was demolished when the Plumstead Road was widened (p. 27).

The first Master Founder of the Royal Brass Foundry was Andrew Schalch, and he resided in official quarters in Dial Square from 1717 to 1770. Following his death two Dutchmen, father and son Jan and Pieter Verbruggen, were appointed to the post and persuaded the Crown to build them a family house in the style to which they were accustomed. This building, Verbruggen's House (p. 28), listed as Grade II, and built in 1773, was subsequently used as home to the Select Committee of the Ordnance Board who controlled the destiny of the Ordnance Factory. Brig. O.F.G. Hogg, the author, was at one time Military Secretary to the Select Committee and my father, G.F. Masters, was also a member of the committee.

Following the visit by George III in 1773, the Warren felt it could ask for more recognition and was granted funds to build an Ordnance Wharf (p. 28). It was built along the riverside on Prince Rupert's Walk and was about 450 yards in length. As time went on, the Thames bank was built up and the river bed dredged to allow large sailing ships and barges to moor right along the Arsenal's shore, to the east of the Riverside Guardhouses.

In 1777 the Board of Ordnance purchased additional land from Sir Thomas Wilson for the purpose of making a new Proof Butt and Storehouse (p. 29). The map shows the Cadet Barracks and the proximity of 'Mr Witham's Farm'.

Between 1717 and 1775 boat-loads of felons were shipped to the Colonies and, when this became no longer acceptable, the Government established floating prison ships known as 'the Hulks'. This led to the mooring off Woolwich of three hulks, the *Warrior, Justitia* and *Defence*, all originally under contract to a private individual, Duncan Campbell. No convict was allowed to be without an iron upon one or both his legs and, if engaged on board, he had to undergo the same restraint as did those convicts who were working during the day on land at the Warren or the Dockyard. Convicts were employed in the Arsenal on a variety of manual tasks including digging canals, building the main wall (p. 30) and, in 1848, building a circular reservoir on top of Woolwich Common. In 1857 the last hulk was burnt at Woolwich following the removal of the last convicts in 1856.

The Main Guardroom (p. 115) is built on the site of an old powder house which, in 1735, was extended to become the first guardhouse, the work being completed in 1788. In the early days of the nineteenth century, security guards were provided by the army. From around 1856 to the 1930s the guardhouse became the HQ of the Building Works Department (BWD) of the Arsenal, responsible for the repair and maintenance of buildings on the site. In recent times, the building was the main pedestrian entrance to the Arsenal but is now closed.

Building C1 was known as the Gun Inspection Shop (p. 30) and was occupied by the Chief Inspector of Armaments, who was responsible for the inspection and quality of the equipment manufactured in the Arsenal.

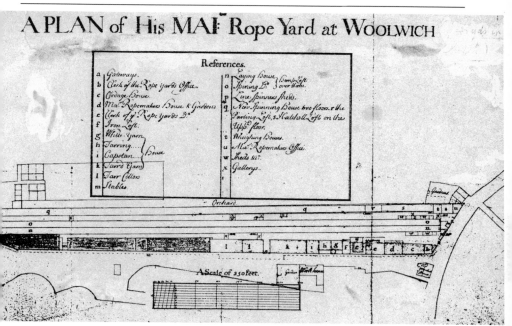

Plan of the Royal Woolwich Rope Yard, which ceased production in 1670. (*The Royal Arsenal: Its Background, Origin and Subsequent History*)

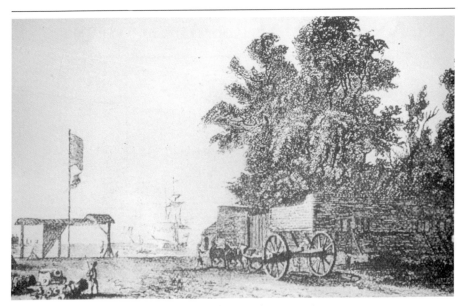

Warren Estate, the birthplace of the Royal Arsenal. (RAWHS)

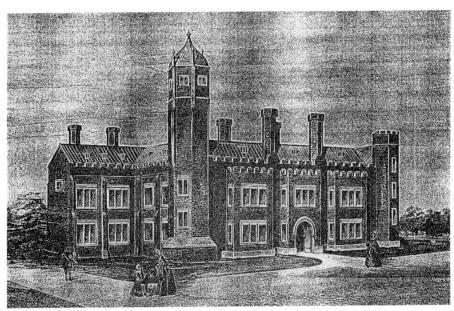

Tower Place in the Warren Estate, *c.* 1473, once owned by the Boleyn family and a Lord Mayor of London.

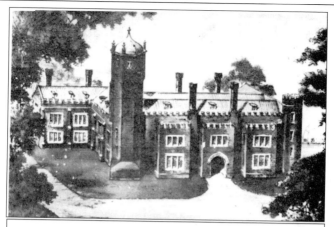

THE TOWER PLACE WOOLWICH

The accompanying picture of Tower Place, Woolwich, temp 1545, was painted by Mr. Joseph Pike from a sketch prepared by Brigadier O.F.G.Hogg after a study of some old plans of the original house. Though not one of the stately homes of England, this Tudor mansion was of considerable size for the period in question standing, as it did, in the Warren close to the small township of Woolwich. In 1662, its owner - Jeremiah Blackman - paid hearth-tax for it on 15 hearths, it being the largest private dwelling in the parish.

The estate when purchased by the Crown in 1671 contained 31 acres and the land comprising it had originally belonged to two religious houses before Henry VIII dispossessed them; St. Mary Overy at Southwark and St.Augustine, Canterbury.

When the mansion was built is not known, but by its architectural style it must have been of recent construction when, on 10 March 1538, Thomas Smythe sold it with other lands in Woolwich and Plumstead to Sir Martin Bowes, goldsmith, Lord Mayor of London, 1545-1546.

The owners of the property have been as follows:-

Sir Martin Bowes	1538 - 1541	Thomas Bowes	1566 - 1568
Sir Edward Boughton	1541 - 1544	John Pears and Alice his wife	1568 - ?
Edward Dymmoke	1544 - 1548	Sir William Barnes (Senior)	? - 1619
Thomas Stanley	1548 - 1557	Sir William Barnes (Junior)	1619 - 1650?
John Robynson	1557 - 1560	Jeremiah Blackman	1650?- 1669
Sir Martin Bowes	1560 - 1566	Sir William Prichard	1669 - 1671

The Crown purchased Tower Place from Sir William Prichard (Lord Mayor of London 1682 - 1683) on 17 May 1671 for the sum of £2957, and the Old Gunwharf, the property being paid for and conveyed on 25 May 1676. The price then paid, including interest and rent, was £3778.19s.1d.

On 17 March 1682, Sir Bernard de Gomme, his Majesty's Chief Engineer, prepared plans and an estimate for dividing "the great house at Woolwich" into apartments for the storekeeper Mr. Thomas Peach; quarters for the Master-Gunner of England, Captain Richard Leeke R.N.; a great bedroom for the Lieutenant of the Ordnance; a great dining room for the Officers of the Ordnance; and accommodation for 12 gunners.

In 1719, the whole house was remodelled and reconstructed by Sir John Vanburgh. He added a new facade, shorter than the original front so that the tower, which had been integral with the old mansion, became detached, as can be seen in the painting of the R.M.A. by Paul Sandby (engraved by Hooker). This tower, or turret as it was afterwards called, was demolished in August 1786. The new front of the house contained two large rooms or "great salons"; one on the right, the other on the left of the new central doorway. The room on the right had a large bow-window and was built as a Board Room for the Officers of the Ordnance. The one on the left was the original Academy of 1720. When the present Royal Military Academy was established 30 April 1741, it took over the old Academy room, while at the same time extensive alterations to the house were carried out. Within were made residences for the first and second masters of the Academy and a new dwelling for the storekeeper. The front doors of the masters' houses can still be seen, while the present kitchen occupies the site of the ground floor of the storekeeper's residence. Other parts of the building were used as the headquarters of the Royal Regiment of Artillery. Gradually the Academy took over the whole building after the Gunners migrated to the Barracks on Woolwich Common in 1778. In 1806, when the Royal Military Academy moved to its new home on the Common near Shooter's Hill, Tower Place was handed over to the Royal Laboratory. After being used as a museum it became the Pattern Room of the R.L., and, on the formation of the Inspection Department, Woolwich, in 1888, it was transferred as the Pattern Room for the Inspector, Laboratory Stores. The patterns were kept in the "Academy" and "Board Room", but when patterns tended to disappear (being replaced by sealed specifications and sealed drawings) the "Board Room" was the first to be emptied, and a few years after the first World War it was converted into a luncheon room for C.I.A. Officers. On the final disappearance of the patterns a C.I.A. Mess was formed in the building after the second World War, the "Academy" becoming the Ante-Room and the "Board Room" the luncheon room.

At one time the Gentlemen Cadets acted plays weekly in the Board Room. The Academy Room was fitted out as the first Chapel in the Warren on 11 December 1750, but this was short-lived. On 1 November 1751, it was ordered that the Board Room at Woolwich should be used as a Chapel in place of the Academy room, and that no more plays should be performed in it.

Though no portions of the old house, save possibly a few bricks, remain, the ground plan of the present building follows closely that of the original manor house. A lineage of at least 400 years can thus be claimed for this message.

A picture of Tower Place by Joseph Pike, and a description of the building.

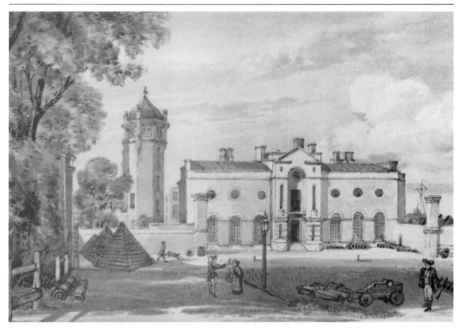

In 1741, when the Royal Military Academy was established, the Boardroom became a chapel for the cadets and staff. The vaulted tower was demolished in 1786. (Paul Sandby)

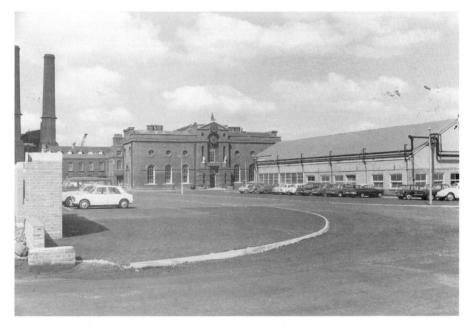

Tower Place when in use as the Officers' Mess.

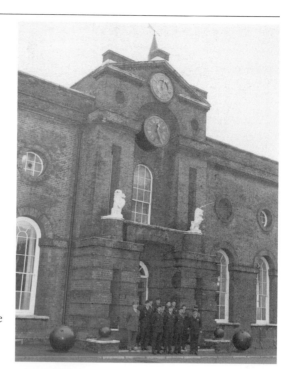

Grand Entrance to the Officers' Mess. The Lion and Unicorn (in white) over the door are from the original Royal Laboratories sea-entrance to the Warren from the Thames (see p. 18).

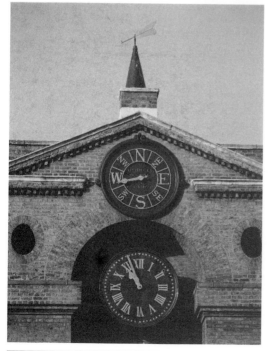

The clock and wind-direction indicator on the front of the Officers' Mess. (RAWHS)

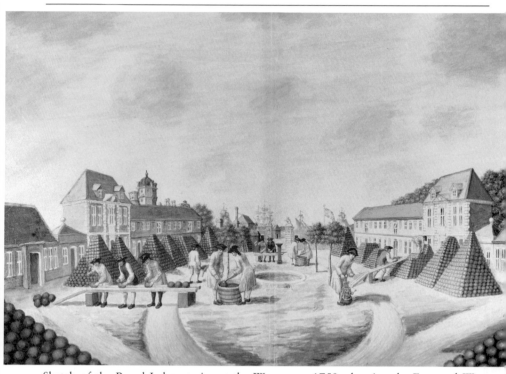

Sketch of the Royal Laboratories at the Warren, *c.* 1750, showing the East and West Pavilions. Notice also the sea-entrance for VIPs arriving by barge via the Thames.

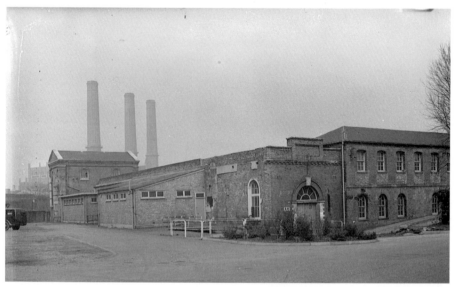

Number 1 Street and Building A15 (Royal Laboratories).

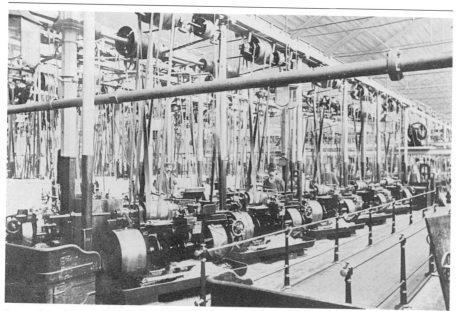

Part of Building A15, the main factory of the Royal Laboratories during the South African wars – automated machines capable of every small and intricate engineering operation. (RAWHS)

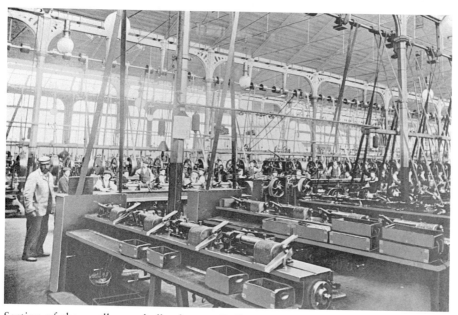

Section of the small-arms bullet factory. Bullets were made here for Martini-Henry, Webley pistol and Mark II magazine rifles. During the South African war this department worked day and night turning out millions of bullets weekly. (RAWHS)

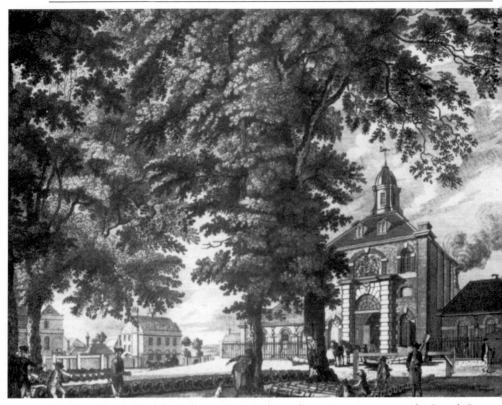

The Royal Brass Foundry. The two crests above the main entrance are the Royal Crest and, below, the coat of arms of the Duke of Marlborough, who was Master General of the Ordnance at that time. (RAWHS)

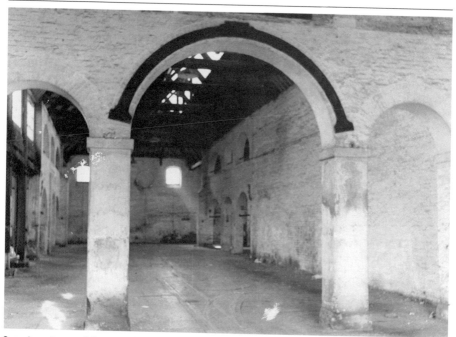

Interior views of the Royal Brass Foundry. (RAWHS)

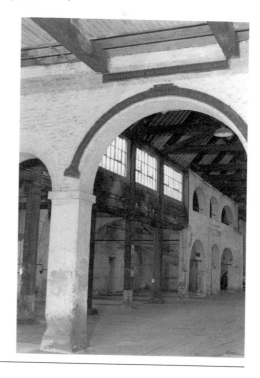

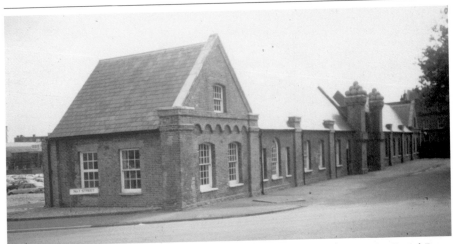

The 'Great Pile of Buildings' which was established at the same time as the Royal Brass Foundry. All finishing work on the cannons was carried out here. The sun-dial, from which Dial Square gets its name, is mounted over the central arch between the piles of stone cannon balls. The 'Arsenal' football team also began here, being formed from workers in these buildings. It was known at that time as the Dial Square Football Club.

Building C13, or the New Wheeler's Shop of the Royal Carriage Department, was built in 1717 and enabled carriage manufacturing operations to be undertaken under cover.

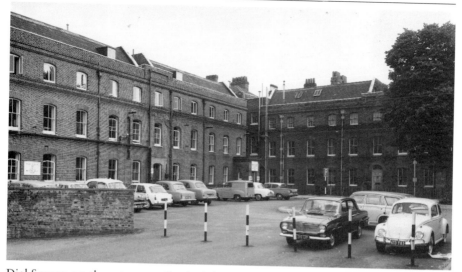

Dial Square, north-east corner. On the left are the old Royal Artillery Barracks, nos 1–4. On the right, at right angles, are nos 5–10. All served at a later date to accommodate officers seconded to duties in the Royal Arsenal.

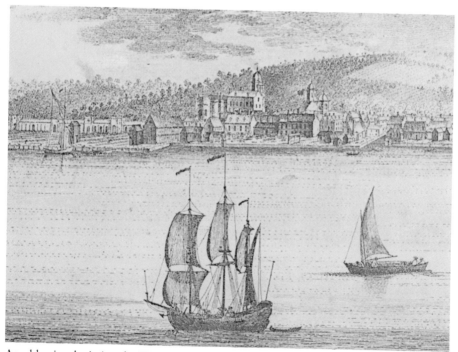

An old print depicting the Warren from the Thames, dated 1739. (S. & N. Buck)

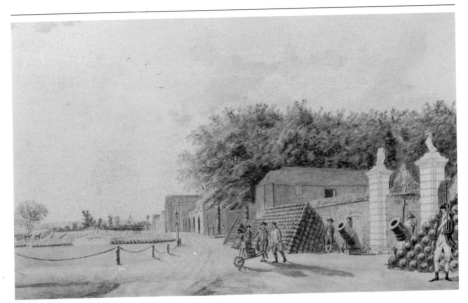

The Warren, 1750. (RAWHS)

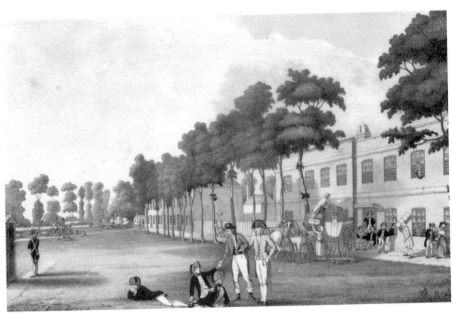

The Cadet Barracks in Avenue 'H'. (RAWHS)

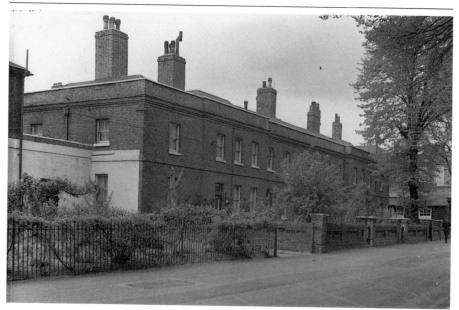

Nos 15–17 Avenue 'H' official quarters (1920–40). Senior staff were required to live 'on site'.

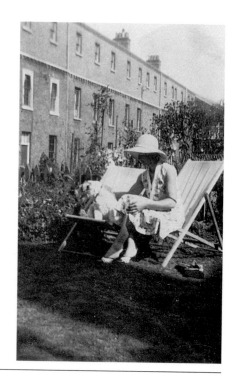

Miss Gwen Masters in the garden at 21 Avenue 'H'.

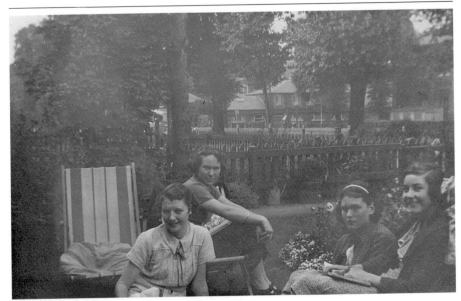

Residents at ease in the front garden of no. 21.

Avenue 'H'.

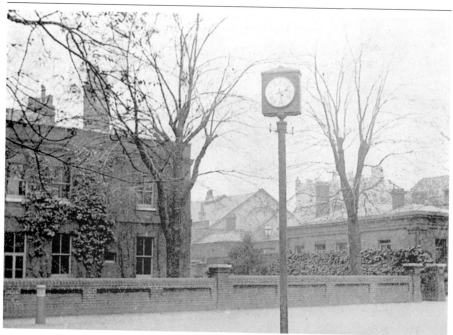

The official clock in the middle of Avenue 'H'. (RAWHS)

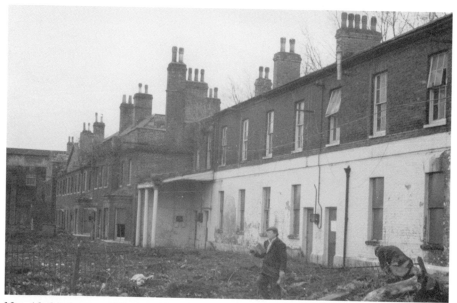

Nos 18–22 Avenue 'H', the old 'Wheelwrights Shop' can be seen at the far end. The photograph was taken in 1984 when the buildings were being demolished in order to widen the Plumstead Road.

Verbruggen's House.
Behind, on the left, can
be seen the buildings of
the Royal Gun and
Carriage Factory's
erection shop.
(RAWHS)

Ordnance Wharf on the riverside.

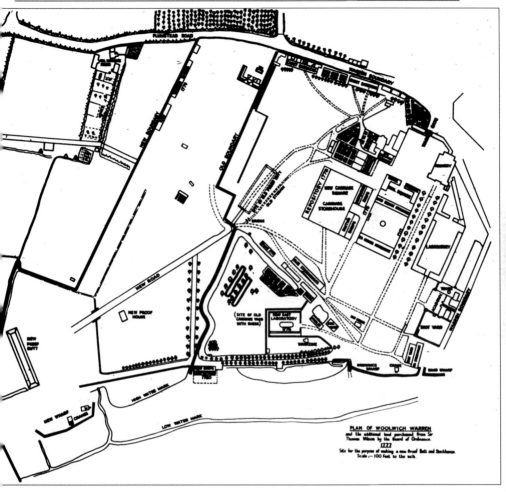

Map of the Warren, 1777. (RAWHS)

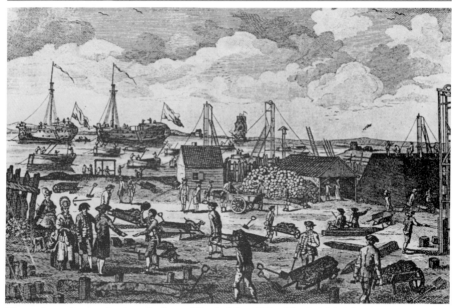

View of convicts and prison hulks at Woolwich, 1779. (The British Museum)

Gun Inspection Shop (Chief Inspector of Armaments) is on the left. The Central Office looms behind it and the RGCF Erection Shop is on the right.

Section Two

THE NINETEENTH CENTURY

At the start of the nineteenth century, Woolwich was developing into a modern military factory as a result of pressures brought about by the Napoleonic Wars. In 1805 George III paid a second visit (the first was in 1773), and suggested that, as the name 'Warren' seemed inappropriate, it should be changed to 'Arsenal'. The Master-General agreed and, as a compliment to the King, instructed that the name would henceforth be The Royal Arsenal.

In 1801, during the period immediately preceding the outbreak of the Napoleonic Wars, a new complex for the Arsenal's Storekeeper's Department was conceived. This building, to be known as the Grand Store (pp. 41–2), served as a general depot for the army and navy for items such as entrenching tools, harnesses, gun-carriages, shot and shell. Built between 1806 and 1813, to a design attributed to James Wyatt, the three principal storehouses have timber-built interiors similar to those of commercial warehouses of that period. Whilst the main buildings are constructed of Purbeck stone, the plinth of the centre storehouse was made of Dundee stone. The eastern end of the building, unfortunately, suffered subsidence within a few years of construction, necessitating expensive rebuilding in 1831. Heating of part of the building was by means of a very large cast-iron stove (p. 42) which still exists today.

The main event of 1803 was the establishment of The Royal Carriage Department (pp. 43–4), to carry out the building and repair work previously done by the master carpenter of the period. The increasing output demanded by the war meant that the gun carriage could no longer be regarded as the Cinderella of artillery equipment. The New Carriage Square developed into the largest complex in the Royal Arsenal; the manufacture and repair of all guns, armoured cars, tanks, mortars and machine-guns were undertaken here when the department merged with the Royal Gun Factory to become the Royal Gun and Carriage Factory in 1907. It began east of the 'Great Pile' and

quickly formed into a quadrangle. Then water was laid on in a fountain in the centre and it became known as Fountain Square. The building was then roofed over to give one huge manufacturing space. The roofing was raised to its present height in 1928.

In 1805, the year of George III's visit, the first 'Congreve Rocket' (p. 45) was introduced into production. Invented by Sir William Congreve, the missiles became one of the standard productions in the Royal Laboratories. The weapon was effectively deployed by Royal Artillery rocket batteries at a number of important battles.

In 1809 it was necessary to find alternative accommodation for the Storekeeper, whose residence had been Tower Place for well over 100 years. For this man of considerable importance, a rather grand house known as Middle Gate House (p. 45) was built in land by the second gate; it may be seen from Plumstead High Street. Among the more renowned residents of Middle Gate House was Sir Henry William Gordon, brother of General Gordon of Khartoum. Sir Henry was Storekeeper from 1858 until 1879 (his title in 1876 being changed to Commissaries-General). In 1920 the Naval Ordnance Inspection Department transferred from Sheffield to Woolwich, occupying Middle Gate House for many years. Naval guns laid out by the main gantry are shown on p. 46.

One of the first 'Pedimental' buildings to be constructed in the Arsenal was the New Laboratory Square (pp. 46–7), dating from 1811. The term 'Pedimental' is presumed to come from the method of construction employed; that is, a framework of pillars filled with brickwork. The need, brought about by the Napoleonic Wars, for greatly increased production of bullets, shells, rockets and propellants, forced the Royal Laboratory to expand rapidly and this fine new building was erected in the triangle between Tower Place and the river. It was built as a square around a courtyard which could, if necessary, be covered over at a later date. This was never done and the building still exists as 41/41a in the north-west corner of the Arsenal. It is interesting to note that it is this building which has been selected as the site of the new Royal Artillery Museum, the financing of which is currently the subject of a fund-raising exercise.

As the Arsenal increased in importance, it became obvious that the site was vulnerable along the river front, particularly as the chief means of transport to the Arsenal was by boat. In 1814–15 two octagonal Riverside Guardhouses (p. 120) were built, on either side of a causeway. The western building was for use by the officers and that on the east for men of the guard. The western guardhouse was used as a mortuary chapel in 1879 when the body of the Prince Imperial rested overnight on its return from Zululand (p. 47). The following day there was an official funeral and memorial service at Chislehurst, where he and his wife had lived in exile.

During the same period, 1814–16, the Ordnance Canal was built, so that barges could load and unload alongside the various factory buildings. The canal was designed and built by Royal Engineers, aided by convict labour, and was almost a mile in length starting at lock-gates (p. 48) where the canal met the Thames. The canal had two dog-legs where it ran between the main factories creating an area known as Frog Island. The dog-legs and part of the straight

used for torpedo trials were filled in some years ago, but part of the canal remains. It has been redeveloped by Thamesmead Town Council, and is now known as 'Broadwater'; to its east commence the Thamesmead Town dwellings. The west bank of Broadwater now forms the boundary with Royal Arsenal West. The lock-gate at first incorporated a narrow footpath and handrail over the southern gates for pedestrian use. A swing-bridge was subsequently built over the exit from the lock-gate (south side), over which ran a railway track for use by trains, tanks, armoured vehicles and pedestrians. A further swing-bridge was built over the canal 400 yards to the south. Thus, from 1900, all vehicular traffic had easier access to the Proof Butts and marshes for trials work.

During the early nineteenth century the 'Model Room' of the Royal Carriage Department was taken over by the Artillery College, Military College of Science (Arsenal Branch), in which practical as opposed to theoretical work was taught, and where lectures on Artillery material, guns, mountings and ammunition were given. The building was most attractive, having very large windows and a huge balcony which ran all around the interior on which displays could be mounted. Soldiers from all over the Empire would attend this building and be instructed in a variety of weapons. The lower photograph on p. 48 shows the building with the MCS logo above the door; the boy is Richard Goodwin, the son of the resident Government Chemist (1930–40). The photographs on p. 49 show other views of the building together with residents of Avenue 'H', either relaxing or swotting for exams. The building was vacated in 1939 when the Military College of Science left Woolwich, and was demolished in order to make way for a large reserve water tank.

With the advent of the Napoleonic Wars, increasingly large quantities of high explosives were stored in the Royal Arsenal. At one time 30,000 tons were stored in magazines at Erith and Belvedere marshes. The risks involved in transporting such material via populated areas using the riverside 'T' and Iron piers caused much concern to the authorities and local residents. It was therefore decided in 1823 to construct a special pier at Crossness (p. 50) at the extreme eastern tip of the Arsenal shoreline and close to the magazine area. The pier was 200 feet long and 30 feet wide, having a depth of water of between 6 and 14 feet at that point depending on the tide. The photograph shows the pier in the 1930s.

The first Iron Railway in the Royal Arsenal was approved in 1824 and ran through the principal storehouses to the shot-piles. The term 'railway' was rather a euphemism as the track was just a kind of tramway over which trucks mounted on metal wheels could be pushed by hand or drawn by horses. It was considerably expanded over the next few years and, when completed in 1854, came under the control of the Royal Engineer Department. It should be appreciated that this so-called Arsenal railway, completed in 1854–5 was no railway in the modern sense. The word denoted nothing more than a network of iron rails laid down between the wharf, the saw-mill and the main storehouses over which timber and other materials in specially adapted trucks could be moved with less effort than formerly by men and horses. It was a self-contained system for internal use only, and steam played no part in its performance, yet it did mark a definite stage in the evolution of the Arsenal

railroad. In 1866, owing to the Crimean War and the advent of steam, it was decided to construct an 18-inch narrow-gauge railway modelled on a similar track in the old London and North-Western Railway Works at Crewe which had been operative since 1862. This first steam-operated Royal Arsenal Railway, subsequently referred to as the RAR, was designed and constructed by men of the Corps of Royal Engineers. The first locomotive, the 'Lord Raglan', inaugurated the new railway in 1873, taking the sharp curves with the greatest of ease notwithstanding the black smoke which poured from its funnel. The narrow-gauge railway proved so successful that by 1900 it covered a large area of the Arsenal, and formed a valuable link between office and shop, storehouse and magazine. It had become the general goods and passenger service (p. 50). A regular passenger service ran between Dial Square and the eastern end of the Arsenal, using rolling stock of 1st, 2nd and 3rd class coaches (p. 51). The staff wore their own special uniforms, and the service ran to a regular timetable. It was necessary to establish a link with the standard wide-gauge track so a junction was introduced at the Plumstead 4th Gate, known as The-Hole-In-The-Wall. Eventually, in 1923, the service closed to be replaced by a single 3rd class accommodation on the standard-gauge system. Whilst most of the track and rolling stock of the narrow-gauge system was destroyed, some survives to this day. The locomotive 'Woolwich' is currently taking tourists around Bicton Gardens in Devon and the last remaining explosives wagon is on display at the North Woolwich Railway Museum.

It was customary to exhibit notable weapons in the Arsenal, one such being the Bhurtpore Gun (p. 51), captured by Viscount Combermere in India during 1826 when Bhurtpore was captured. A bronze gun, cast in 1677, it measures 16 feet in length, about 8 feet high, with an 18-inch calibre and weighs 17 tons. A fine example of Indian gun-founding, it may now be seen on the parade ground of the Royal Artillery, Woolwich Common.

Adjacent to the Main Guardhouse is the Beresford Square Gate (p. 52) which was the original main entrance to the Arsenal. Built in 1828, each gatehouse supported a light mortar cast in the Royal Brass Foundry. The iron gates were cast by John Hall of Dartford and are still in place; they incorporate the letter 'B' in their design in honour of the then Master General of the Ordnance, Viscount Beresford. In 1859 two further floors were added to the west side, including a bell tower. Further alterations were made in 1889 and 1891. Extensive repair work has been carried out during 1995 at the behest of Greenwich Borough Council, and the gates have now been restored to what must be something like their original appearance. The original entrance to the Arsenal is shown in the top photograph on p. 53. Other entrances to the Arsenal are shown on pp. 53–5.

As the Arsenal did not have its own church, the workers originally used St Lawrence's, afterwards renamed St Magdalene's Church, near to the ferry. This soon became too small to cope with workers from the Dockyard and the Arsenal. In 1778 a small chapel on the site of the present Woolwich covered market was acquired and the Ordnance Chapel (p. 55) built. It became the covered market in 1929. The Garrison Church (p. 56) was built on the Royal Artillery Parade Ground in 1808.

The Gun-Yard appeared for the first time on the guide map of the Arsenal dated *c.* 1850. It was situated to the south-west of the Gas-Works and measured some 300 by 200 yards. The south-east border ran along the canal bank.

The photographs on p. 56 (lower) to p. 58 (upper) are believed to be some of the oldest in existence relating to the Royal Arsenal, the area photographed being that termed the Military Store Department. The location is between the north-east corner of New Laboratory Square and what was later the Shipping Office. The Riverside Guardhouses (before being enclosed with brickwork) are clearly visible in the picture on p. 56, and this same photograph shows the building on the right to have a standard wall-lamp of the period. A general view of the Royal Arsenal at that time is shown on p. 58 (lower photograph).

Whilst the Gas-Works (p. 59) played an important part in the running of the factory, supplying gas, heat and lighting to the factories, it did not feature in many photographs of the Arsenal. Built in 1848, a second gasholder was added in 1862 and the works were finally enlarged and modernized in 1900.

The layout of the Royal Arsenal is shown in the 'Guide Map of the Royal Arsenal Woolwich' (p. 60), dated 1850. In particular, the map clearly shows the layout of the Canal and a recommended route for visitors.

After the outbreak of hostilities in the Crimea in 1854 there were shortcomings in the quality and supply of guns for the British army. The guns in use were heavy, unreliable and inaccurate. The Government also did not have the machinery to produce its own guns and was forced to pay the high prices demanded by private manufacturers. In order to correct this situation Mr Anderson, the Superintendent of Machinery, acquired new machinery from a variety of sources and, in 1856, a gun factory was erected to manufacture iron ordnance. Originally Building 25, it is now known as the Armstrong Gun Factory and is situated at the eastern end of the Grand Store. Cast-iron was considered to be no longer the preferred material for gun manufacture and, instead, it was decided to produce Sir William George Armstrong's coiled wrought-iron guns in the new factory. Armstrong devised a method whereby coils of white-hot wrought-iron were hammered together to form a gas-tight tube. By welding lengths of tubing together and shrinking a number of tubes over one another a stronger, more powerful, yet lighter gun could be produced. A drawing for a Field Carriage for 12 pdr Armstrong Breech Loading Gun is shown on p. 61. An Armstrong light gun is shown on p. 62. By 1870 the Royal Gun Factory at Woolwich, the State's only supplier of guns for Britain, was producing guns of 35 tons in weight, known as 'The Woolwich Infant'. By 1875, 80 ton RML guns were introduced for the Navy (pp. 62–3) and, in 1876, the Rink (p. 63) was constructed, complete with radial crane (p. 64), for handling and heat-treating the bigger guns. In 1882 the South Boring Mill was constructed for the manufacture of heavy guns (p. 65).

In addition to the extensive manufacturing facilities of the Arsenal, the Royal Laboratories operated the Research Department, which originally was located near the 4th Gate. The department consisted of many hutments (p. 66) where research was carried out into explosive materials and devices. In due course this facility grew into the Armament Research Department and, later still, the Armament Research and Development Establishment which

eventually transferred to Fort Halstead, near Sevenoaks, Kent, becoming the Royal Armament Research and Development Establishment (RARDE).

The Medical Department, situated in Building A79 Avenue 'H' (p. 67), played an important role in the Arsenal and in 1889 the Royal Army Medical Corps (RAMC) staff comprised two surgeon-majors, one surgeon, one dispenser and one dresser. Quite extensive facilities were available in the form of a six-bed hospital, surgery and mortuary (pp. 67–8). Just east of the surgery, through a covered pathway, was a small shady green with a summer-house and garden chair where waiting patients could rest. A range of treatments could be carried out on site, including amputations and hernia operations. One record book states that permission was granted by the authorities for a surgeon-major to keep a cow on Woolwich Common. This was apparently required in order to have a supply of fresh milk which, at that time, was used to treat cases of lead poisoning caused through handling explosives. As a back-up to these facilities, there was of course the medical staff of the RAMC at the Royal Herbert Hospital at Shooter's Hill. The Arsenal medical service was eventually put on a civilian basis and a well-equipped medical centre existed until closure of the site.

Tailoring was a very important part of the manufacturing operations carried out in the Arsenal, as a vast number of items were made from paper, cardboard, leather, felt, and all types of material. These materials were required to be fashioned into cartridge-bags, felt pads for equipment and protective clothing for the staff. Before 1855 tailoring was carried out by private industry and was the poor relation of the Royal Laboratory. In 1855 a new factory was built in the 4th Gate Road and, under the impetus of the Crimean War, it prospered, becoming an essential part of the establishment. In 1925 the building was completely destroyed by a fire which raged for three days before coming under control. The 'Tailor's Shop' (p. 68), as it was known, was rebuilt, and it was in operation through both world wars.

On 3 February 1855 approval was given for a portion of the foundry originally planned for the Royal Laboratory to be used as a Shell Foundry (p. 69). A noteworthy feature was the incorporation of a chimney 233 feet 9 inches high containing 290,000 bricks, the first being laid on 2 April 1856. The foundations consisted of concrete 38 feet square and 23 feet deep with courses of York landings. The foundry was completed in 1856 at a cost of £55,000, thus exceeding the estimate by £20,000. The Rifle Shell Turnery Department (pp. 69–71) was added to the foundry as an extension in 1867. To complete the rather grand entrance, a pair of magnificent gates were designed by Mr Charles Bailey, cast at the Regents Iron Works and bear the date 1856 (p. 71). The gates remained until the closure of Royal Ordnance Factory, Woolwich in 1967, following which they were removed to ROF Patricroft at Manchester. In 1990 the gates, together with the matching window grills, were kindly returned to the Royal Arsenal by RO plc and were restored to their former glory. Whilst today only the entrance arch and elegant gates remain, it is interesting to read the following description of the foundry in Wm. Thos. Vincent's late nineteenth-century *Woolwich Guide to the Royal Arsenal etc.*: 'Shot and Shell Foundry: The entrance to this building lies through a pair of noble gates of cast-iron, having screens of the same material and pattern to the

office windows on either side. These gates and screens are probably the most beautiful specimens of their kind to be seen in England. On entering, the visitor will be somewhat startled by the grim contrast within: for, save for the livid glare of the molten metal streaming in cataracts from the furnaces, or, in seething cauldrons borne through the gloomy shades of this inferno, scattering their dross in fiery stars over the iron floor, all is black as night. But it is questionable whether there is another large foundry in existence so neat and yet so perfect – ay, so cheerful, as this.'

During 1854 and 1855 the Ordnance Select Committee examined a large number of ideas for improvements to artillery. One came from an engineer, Robert Mallet, who had conceived the design of an enormous mortar built in sections so that it could be transported in pieces and assembled on site. Originally intended for the siege of Sebastopol, the mortar weighed 42 tons and had a calibre of 36 inches. Two prototype Mallet's Mortars (p. 72) were constructed although, by the time they were completed, the Crimean War had been over for more than a year! October 1857 saw the very first firing of Mallet's mortar on Plumstead Marshes: this resulted in fractures appearing in one of the exterior rings. The project was eventually abandoned; the mortar used for proof firing may be seen in Repository Road, Woolwich Common, opposite the entrance to the Royal Artillery Barracks. The second, untried, mortar stood in the Royal Arsenal for many years but is now on display at Fort Nelson near Fareham, Hampshire.

Because of the need to speed up the loading of munitions during the Crimean War, the building of an Ordnance Pier was authorized in 1856, and the 'T' Pier (p. 72) was designed and constructed by the Royal Engineers again using convict labour. Built mostly from timber taken from the old St Katherine's Dock, it stood 150 yards into the Thames with 100 yard 'T' arms east and west. It was opened by Queen Victoria just after the end of the Crimean War and welcomed returning troops. In due course, large cranes were added to the pier to allow handling of the guns that were manufactured in the Arsenal. Other large cranes were also in use in other parts of the Arsenal (p. 73). In 1868 the Iron Pier (pp. 73-4) was constructed under Royal Engineers' supervision and the 200 ton crane was added in 1915. From this pier the heavier guns were lowered into the barges *Gog* and *Magog* for transport to the Shoeburyness Gun Proving Establishment. Two hundred yards further down river was the Coaling Pier (p. 74) built in 1878 to carry coal from the colliers to the Gas Factory (p. 75). It functioned until 1949 when the SS *Royal Star* collided with the eastern end of the pier when backing out of the Royal Albert Dock.

In 1855-6 Building 17 was erected as a Paper Cartridge Factory to designs by Lt.-Col. R.S. Beaton RE, manufacturing paper cartridge bags and percussion caps. By 1932 the building was in use as an RAF Bomb Shop and, subsequently, became the Metallurgical Department (Building A46), for the Royal Ordnance Factory (p. 75).

In 1848 a statue of the Duke of Wellington (p. 76) was carved in fine marble by Thomas Milnes who presented it to the Board of Ordnance. Erected in the Tower of London in 1849, it was transferred to the Royal Arsenal in 1863, and was displayed near to the Grand Store. In 1974 a memorial site was

established close to the Central Office Administration block, and the statue was moved to this new location (p. 77). The particularly fine cast-iron work incorporated in the wall of the memorial originated from the buildings which had originally adjoined the central pavilions of the Royal Laboratory. The frieze depicts cannon, cannon balls, Royal cyphers and reproduction of ordnance parts. The larger cannon are of the type used in the Battle of Waterloo. They are Smooth Bore Brass 6 pr Cannon, and it was this type of gun that was constantly in action more than any other during the period 1820–60. The cannon on the left of the statue is dated 1850 and probably saw service in the Crimean War (1853–6) and the Indian Mutiny (1857–8). The one on the right is dated 1855 and, it is suspected, was not used in any campaign. In both instances the carriages are not authentic. The smaller cannon are Smooth Bore Bronze 3 pr Cannon, which by the end of the Napoleonic Wars had become obsolete as field guns. They are contemporary with the Duke of Wellington: the one on the right is dated 1807 and that on the left 1813. All four cannons were made at Woolwich and have now been returned to the Tower Armouries from whom they were on loan.

Whereas there were approximately twenty powder magazines in the Arsenal during the mid-nineteenth century, only one serious explosion occurred. On 8 October 1864 the *Illustrated Times* recorded that there had been an explosion in a powder magazine near Erith (p. 78). A further spectacular event occurred in the Rocket Establishment on 24 September 1883, 'a day of peril, marvellous escapes, terror and anxiety'. A fire in the factory resulted in a shower of Hale's War Rockets descending on houses, gardens and open spaces, sweeping the neighbourhood in all directions. Yet in spite of this, only two people lost their lives. Many had narrow escapes – a foreman, Mr Buchanan, was sitting at his desk when one of the ignited rockets came through a window, passing within a few inches of his head before flying out through the opposite window. A spectator in North Woolwich saw a rocket, weighing about 28 pounds and 18 inches in length, come across the river and bury itself 3 feet into the ground. On looking towards the river he saw about twenty more rockets thrown to a great height and then fall back in the Thames.

During the middle of the nineteenth century, warfare was being revolutionized by the new explosives stemming from the development of organic chemistry. Following the discovery of gunpowder some six hundred years earlier, nitroglycerine was prepared in 1845 and guncotton developed. Another new explosive, picric acid, was also discovered a few years later. The almost simultaneous appearance of these powerful new materials of hitherto unimagined violence must have struck the military minds of the time with something like the same impact as the atomic bomb of our own age. It was, therefore, considered necessary to have expert advice on the subject, particularly as preparations were by then in hand for the Crimean War. To this end a young man, Frederick Augustus Abel (p. 78), was appointed as chemist to the War Department in 1854 with the title WD Chemist. Although only twenty-seven at the time of his appointment, Abel was soon to demonstrate his ability, inventing Cordite, developing new methods of testing explosives and carrying out research into all aspects of explosive technology. The 'Heat Test'

and 'Flash Point' methods of test devised by Abel are still in use today. Abel was one of the greatest scientists of his day. In 1860 he was elected Fellow of the Royal Society and, in 1883, the State recognized his work on explosives by knighting him. Much of Abel's work was carried out in the Chemical Laboratory (p. 79) which was constructed in 1864 to a design in the Colonial style. It was the first custom-built chemical laboratory in the Arsenal. The large room on the west side is the full height of the building to disperse fumes, and also has an ornate cast-iron gallery from which Abel would lower a wicker basket containing samples and instructions to his assistants. The east wing housed a photographic department.

Timber was a very important material in the Arsenal during the nineteenth century and it was therefore necessary to have extensive timber stocks and saw-mills. New saw-mills (pp. 79–80) were constructed in 1867 under the control of the Royal Carriage Department, the design including transporter cranes for moving the very large logs.

A plan of the Royal Arsenal dated 1868 shows the 'T' pier for the first time, also the route of the Ordnance Canal. By this date the western end of the site had become congested, owing to the additional buildings constructed during or after the Crimean War.

The earliest recorded proof testing of cannon in The Warren was in 1651, the old butts being demolished and rebuilt in 1837. By 1870 the Royal Engineers had taken over responsibility for proving guns; normally there were three butts for artillery use and several smaller ranges for small-arms work (p. 80), testing mines, etc. The proof firing of an experimental 11 inch BL gun is shown in the photograph on p. 81.

One of the most famous guns on display in the Arsenal was the Maltese Gun (p. 82), dating from 1607. Captured from the Maltese in 1670, it stood on a small triangle of grass outside Verbruggen House with the muzzle pointing menacingly through the main (Beresford) gate. It was truly a thing of beauty, green with age, 19 feet long, 6 inches in calibre and weighing 115 cwt. The ornamental engraving and adornment were a perfect example of the art of gun making. In order to display this exceptional piece, it was mounted on an equally ornamental gun-carriage, bearing the coat-of-arms of the Duke of Wellington, the carriage being made in the Royal Arsenal. In the mid-30s it was removed to a place of honour on the Royal Artillery Parade Ground.

By 1876 the guns and shells they fired had become so powerful that it was no longer feasible to proof fire them over the restricted length of the Royal Arsenal butts. It was therefore decided to carry out such proof at Shoeburyness where sufficient space existed. In order to transport the huge guns to Shoeburyness from Woolwich, two special barges, *Gog* and *Magog* (p. 82), were constructed to be towed behind a War Department tug. They were an unusual sight but one familiar to the Arsenal workers. Each barge was fitted with railway lines in the hold so that guns could be lowered into the barge by crane at Woolwich (p. 83) and run out, using a railway line, to the butts at Shoeburyness. The barges were fitted with a front which could be lowered to facilitate this operation. Further details of the two barges are as follows:

Gog: Built in 1886 and fitted with railway lines to take gun railway wagons. Length 105 feet, beam 30 feet, draught 7.2 feet. Displacement 400 tons. Built at a cost of £3,025. Sold to R.L. Baker, Canvey Island, on 7 November 1956.

On 16 November 1928, the barge became waterlogged in a Force 10 gale whilst carrying a 52 ton gun from Woolwich to Shoeburyness. The gun shot through the stern gates, which had been carried away. *Gog* was taken in tow by a Trinity House tug the following day and salvaged, but subsequently was only rarely used for carrying guns and spent a great deal of her time as an accommodation vessel until finally sold. The gun evaded discovery for over six months; when raised a further six months later, it was found to be fit only for scrap.

Magog: Built in 1900; also fitted with railway lines. Length 90 feet, beam 30 feet, draught 7 feet. Displacement 260 tons. Built at a cost of £3,355. Sold to Messrs Pocock of Rotherhithe on 31 May 1950.

The map of the Royal Arsenal in 1850 shows the straight, northerly section of the Ordnance Canal labelled as the 'Torpedo Range'. Experiments with torpedoes had started at about that time, the 'Harvey Torpedo' (p. 84) being more like a guided mine which was towed in the water. Later, between 1877 and 1910, a Torpedo Factory occupied the west bank of that section of the canal, and was used to test the more sophisticated torpedoes which had been developed by that time (p. 85). In 1913 it was necessary to transfer the department to Greenock, on the Clyde, as there was insufficient free water in the Arsenal canal to test the modern torpedoes.

In 1879 HMS *Thunderer* suffered a severe accident in the Mediterranean when one of her main guns burst during exercises. Whilst, initially, there was some conjecture that the failure was due to a fault during manufacture by the Royal Gun Factory, it was later established that it was caused by a double charge being loaded at sea (p. 86).

Whilst to the west of the Canal factories manufactured 'inert' items in steel, brass, wood, leather, fabrics and paints, on the eastern side were the so-called Danger Buildings. These comprised the Royal Filling Factory and Research Department buildings where explosive materials were handled and shells were filled (pp. 86–8). There was an extensive railway system in this area, including sidings providing access to the national network.

Electricity was originally installed departmentally but, in 1891, the erection of a Power Station (pp. 88–9) was begun to the east of the Grand Ordnance Store. It was completed in 1908 although improvements took place over the following years. By 1938 the station had to be duplicated in order to keep up with demand.

The last half of the nineteenth century saw the beginning of a fleet of steam cargo vessels to be operated by the War Department Fleet. The first acquisition of water transport by the Royal Laboratories was a large rowing boat, purchased for £35 5s in 1789, for use of the Board of Ordnance at the Warren. This was employed to ferry goods and staff from the eastern wharf to ships in the Thames. By 1812 the 'fleet' had increased to: Two ferry barges of 40 tons,

capacity forty horses; One ferry barge of 12 tons; One horse boat of 6 tons; Two four-oared boats; One two-oared boat; One lug-boat of 10 tons, with sails; One lug-boat of 7 tons, for rowing only; One small lug-boat; Ten lighters and six barges of about 40 tons each; Three skiffs. The persons employed with this fleet were: One Superintendent at 4s per day; Two Masters at 3s per day; Ten Bargemen at 2s 3d per day each; Sixteen Lightermen at 3s per day each.

Sailing ships (p. 89) were introduced by 1841, for example the *Nettley* and *Lord Vivian*, and were followed by steam ships. These were all sea-going vessels, based on the Royal Arsenal and owned by the Royal Laboratory. The upper illustration on p. 90 is of *Sir Evelyn Wood* in 1884. In 1892 a War Department Fleet was established under the Assistant Director of Military Transport. It is now administered by the Royal Corps of Transport (p. 90, lower picture).

The vast interior of the Grand Store (ground floor). (RAWHS)

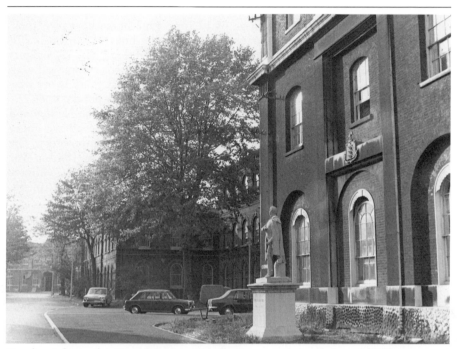

On the right is the Grand Store, with the statue of the Duke of Wellington and Ordnance arms on the wall above. On the left is the Laboratory of the Government Chemist.

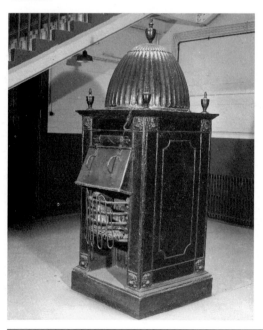

The cast-iron stove, installed in 1812, for heating staff offices in the Grand Store. The office of the Master General of the Ordnance was on the floor above. (RAWHS)

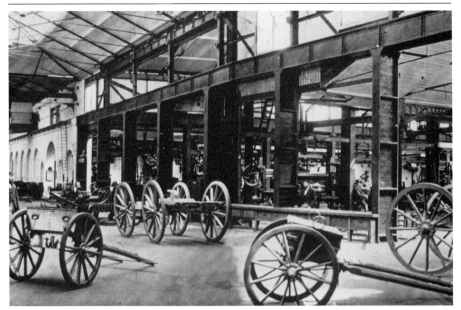

Royal Carriage Department (RCD), 1874. Building no. 10 which produced gun-limbers. (RAWHS)

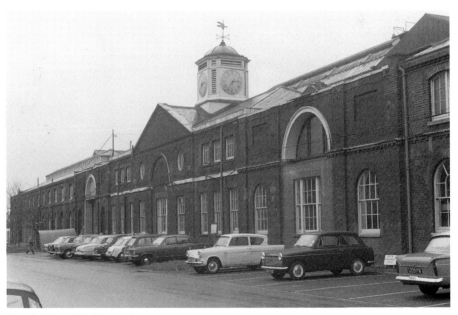

North side of Building 10.

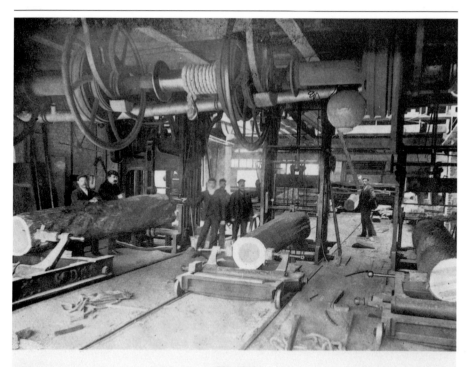

SAW MILLS

The Mills are equipped with powerful Machinery for wood cutting. The trunk of tree shown in the Machine is being cut into planks one operation.

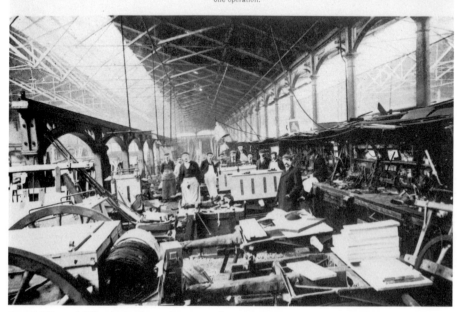

Saw-Mills and Wheeler's Shop, the start of many a gun-carriage. (RAWHS)

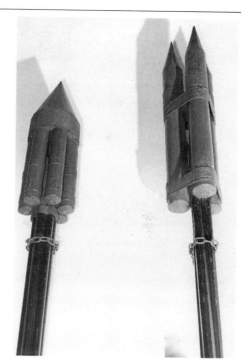

'Congreve Rockets' on display in the Officers' Mess. (RAWHS)

Middle Gate House – originally built for the Ordnance Storekeeper but later occupied by the Naval Ordnance Inspection Department.

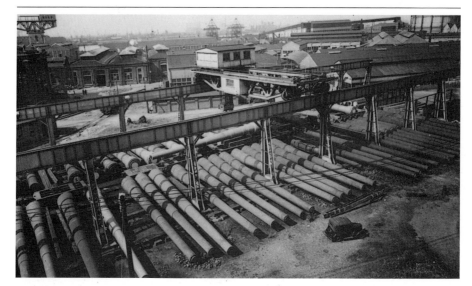

Heavy Naval gun handling facilities in the Gun Yard. Note the large crane in the background.

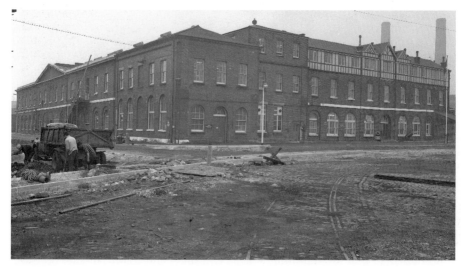

Royal Laboratories, New Square, later referred to as the Pedimental Buildings.

Pedimental Buildings, the eastern wharf and the two Riverside Guardhouses.

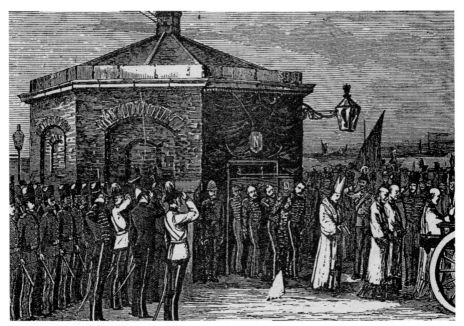

The western Riverside Guardhouse, where the body of the Prince Imperial rested overnight, before the funeral at Chislehurst. (*ILN*)

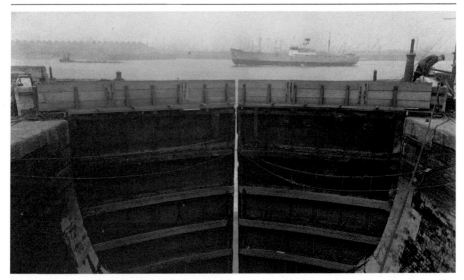

Lock-gate and foot-bridge of the Ordnance Canal. The river Thames is in the background. This is now all part of Thamesmead New Town.

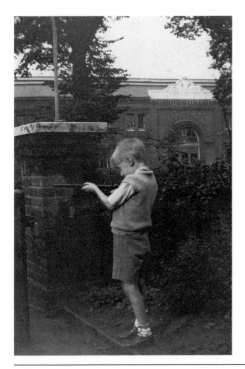

Master Richard Goodwin, son of the resident Government Chemist, 1937. The logo of the Royal Carriage Department is to be seen over the main door. (Mrs E. Fisher)

The southern face of the Artillery College (Military College of Science).

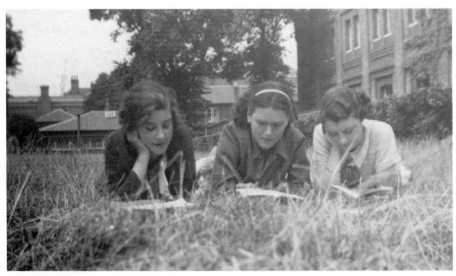

Miss Bridget Crowley, Miss Eileen Affleck-Graves and Miss Iris Bloodworth (residents of the official quarters) at ease on the green between the Management Quarters and the Artillery College, 1935.

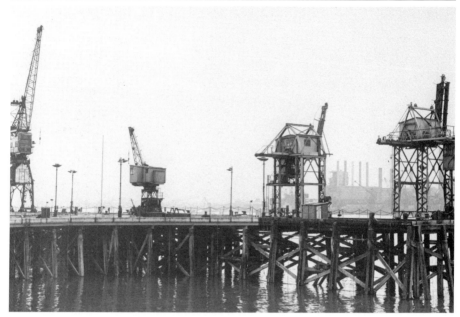

Crossness Pier, used only for loading/unloading live ammunition and explosives. (RAWHS)

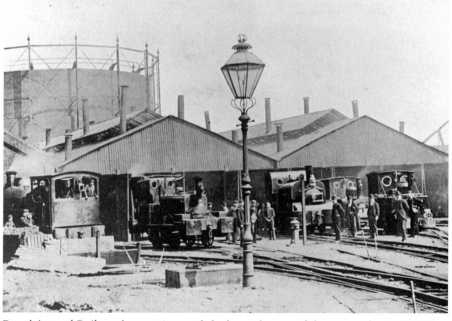

Royal Arsenal Railway locomotives and sheds south-west of the gas-works. (RAWHS)

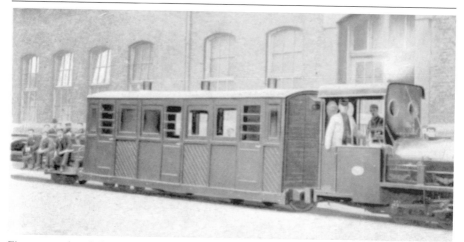

First, second and third class! (RAWHS)

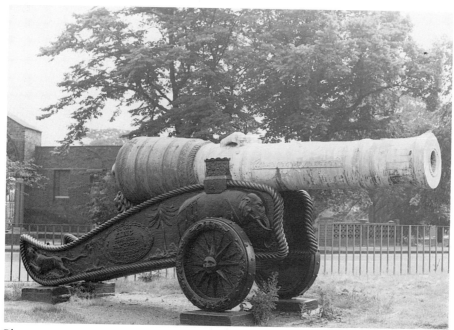

Bhurtpore Gun, when it stood in Dial Square. (RAWHS)

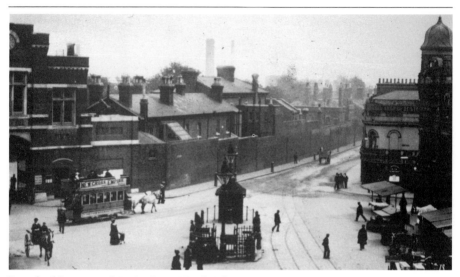

Beresford Square and Main Gate, Woolwich.

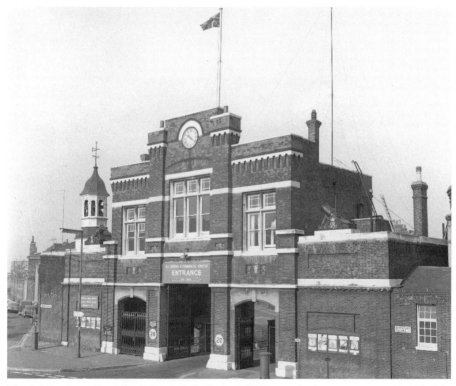

The Main Gate, Beresford Square. Built in 1828, two further storeys were added in 1859.

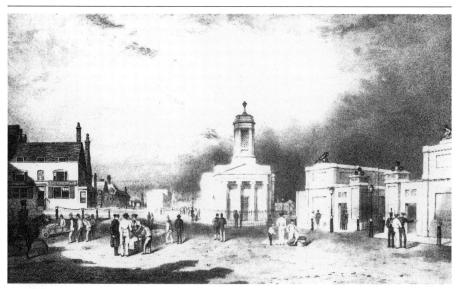

Beresford Gate, showing Holy Trinity Church and Beresford Square, 1835. (RAWHS)

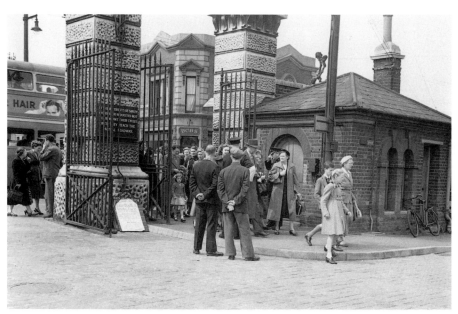

The Second Gate, Plumstead Road. (RAWHS)

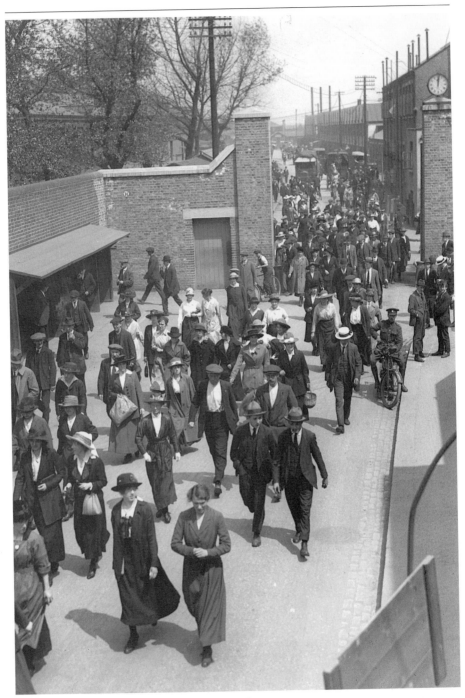

The Fourth Gate, by Plumstead station. (IWM)

'Berber' or Abbey Wood Gate.

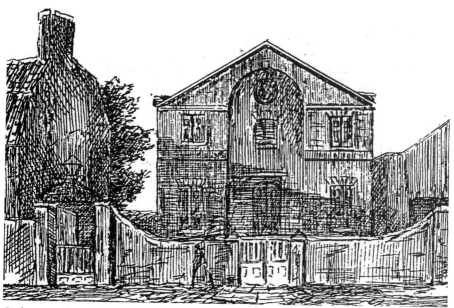

Ordnance Chapel, 1830. (*Woolwich Arsenal: Its Background, Origin and Subsequent History*)

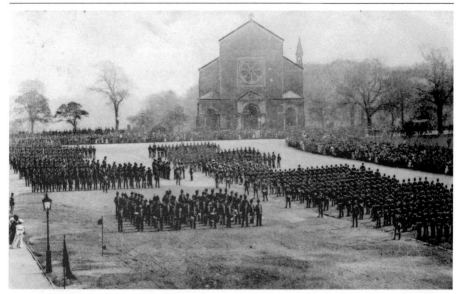

Garrison Church, New Road, Woolwich. This was destroyed by bombing during the Second World War. (RAWHS)

Gun and shell storage, Gun-Yard, Riverside Guardhouses and Pedimental Building. (RAWHS)

Warren Gate and view near Royal Laboratories. (RAWHS)

View near Royal Laboratories. (RAWHS)

View near Royal Laboratories. (RAWHS)

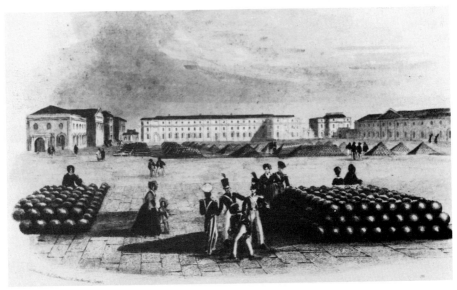

General view of the Royal Arsenal, 1847. (RAWHS)

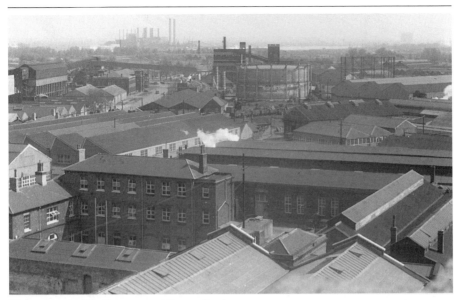

View towards Gas Factory and Power Station.

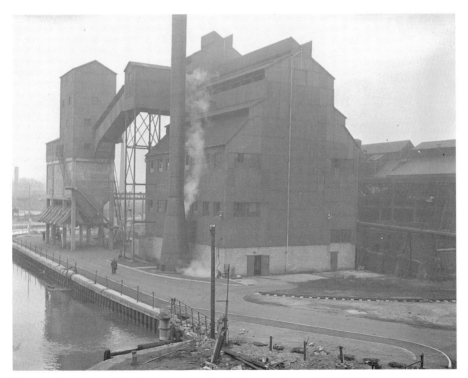

The Gas Factory and lock entrance to the Ordnance Canal. (RAWHS)

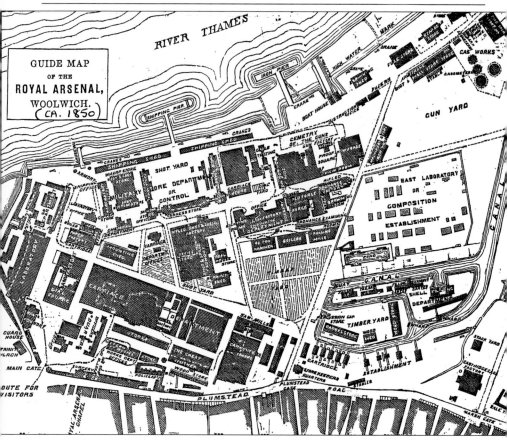

Map of the Royal Arsenal, *c.* 1850. (W.T. Vincent)

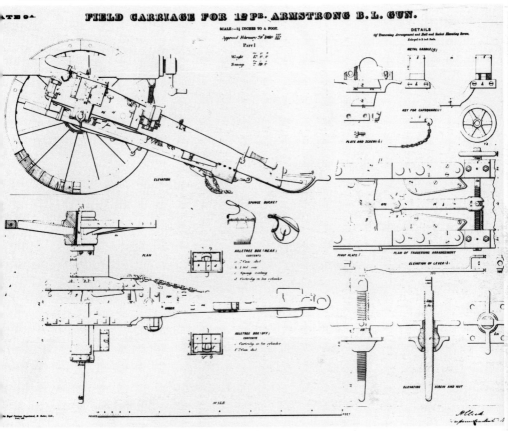

Drawing of Field Carriage for Armstrong 12 pdr RBL gun. (GFM)

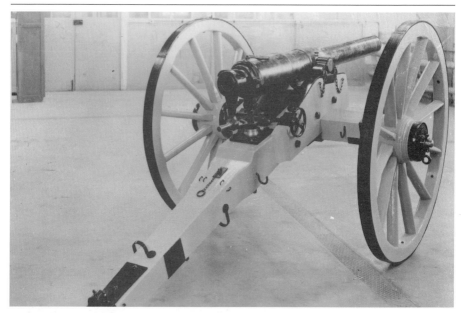

A light Armstrong RBL field gun. (GFM)

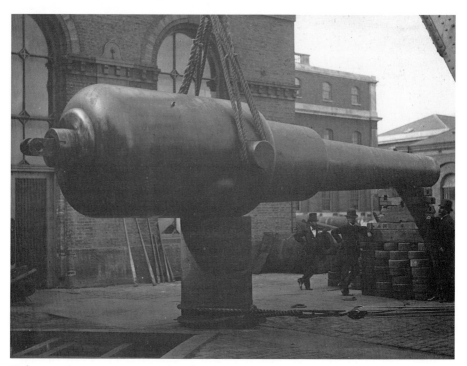

Eighty ton Armstrong gun, produced in 1875. (RAWHS)

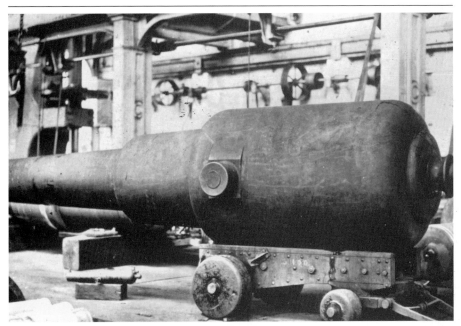

Armstrong gun in the Royal Gun Factory. (RAWHS)

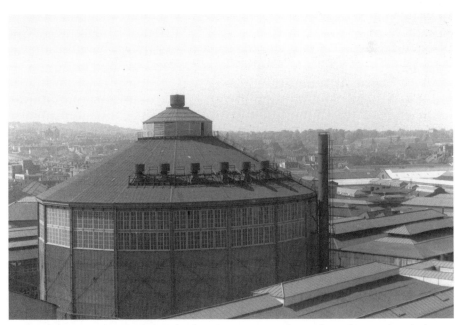

The 'Rink' gun shop, where the heat treatment of gun barrels was carried out. (RAWHS)

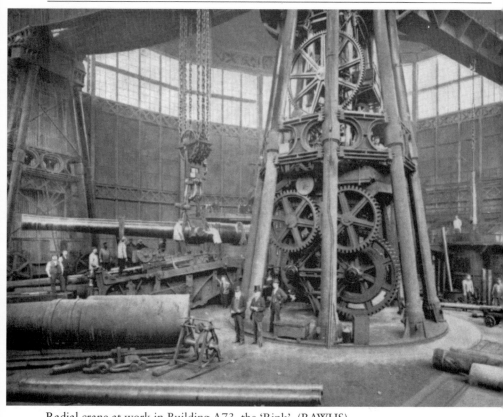

Radial crane at work in Building A73, the 'Rink'. (RAWHS)

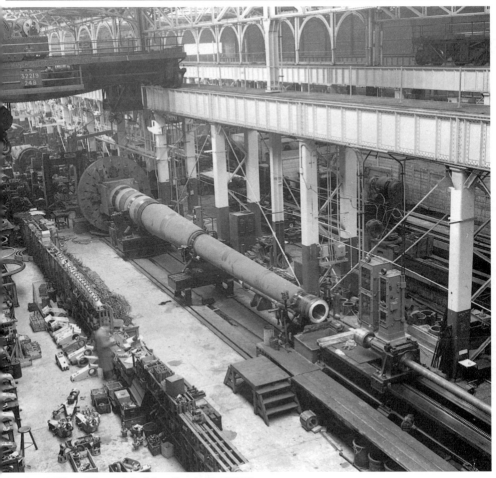

Boring Mill or 'Heavy Machine Shop'. (RAWHS)

A typical isolated research building in the Danger Area. (RAWHS)

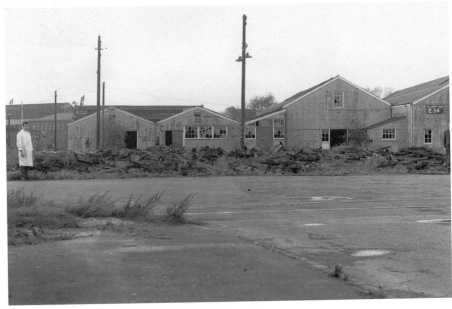

Building E34, another Research Department building.

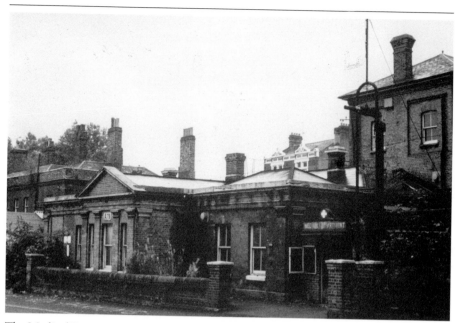

The Medical Department Surgery – very convenient for the residents of Avenue 'H'.

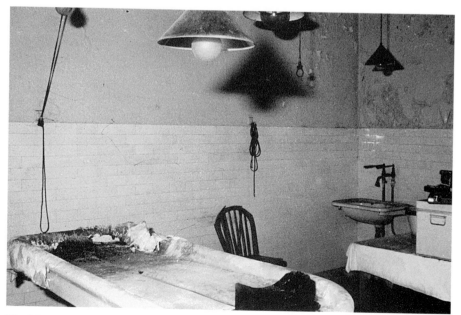

The Mortuary.

The entrance to the Mortuary.

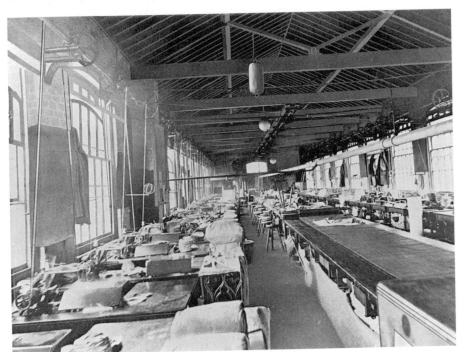

The 'Tailor's Shop'.

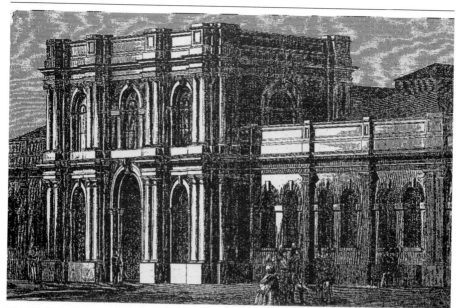

The Shell Foundry, 1856. (*The Building Engineer*)

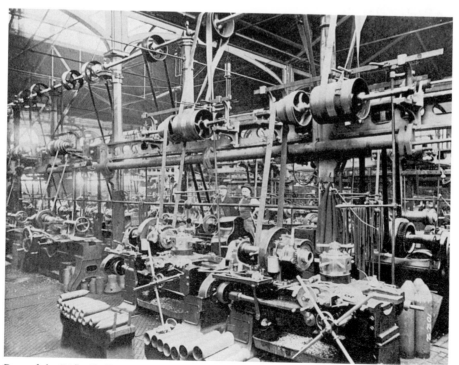

Part of the Rifle Shell Turnery Department. (RAWHS)

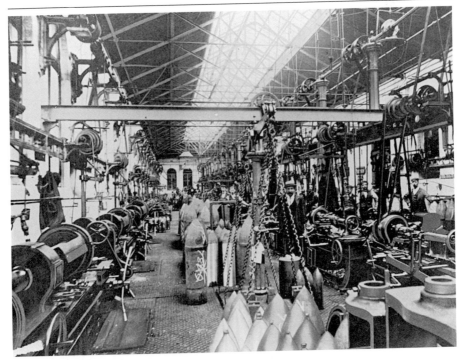

Rifle Shell Factory, Building No. 30.

Rifle Shell Factory, Building A68/69.

Rifle Shell Factory.

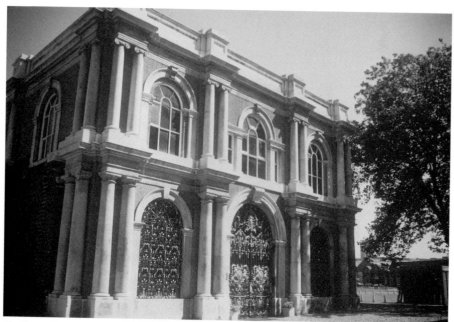

Shell Foundry, showing the wrought-iron gates. (AT)

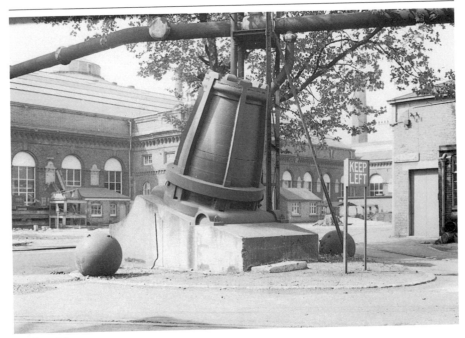

Mallet's Mortar.

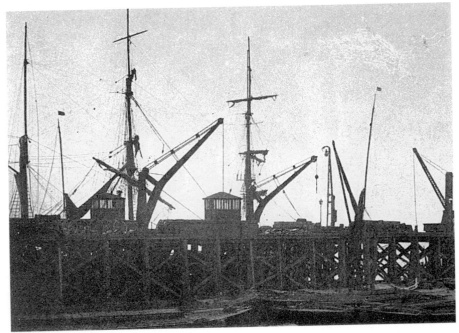

The 'T' Pier, 1920–30. (NMM)

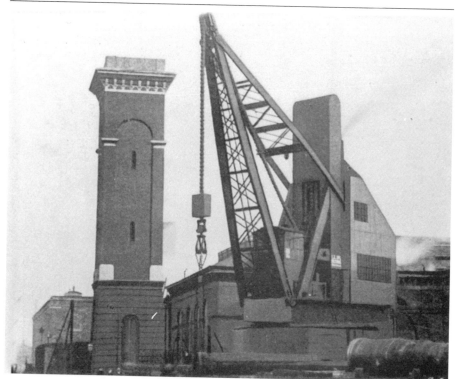

The Grand Storehouse crane. (RAWHS)

Iron Pier and eastern wharf: note the three chimneys of the then Woolwich Power Station. (Thamesmead Town)

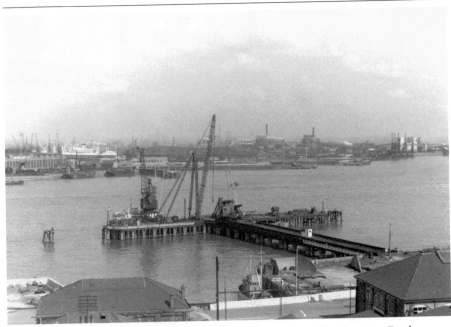

Iron Pier, 1960. The 200 ton crane is missing, having been sold to Antwerp Docks.

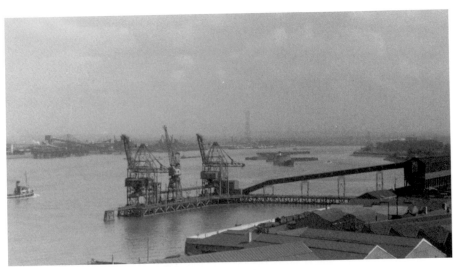

Coaling Pier, as seen from the Power Station roof.

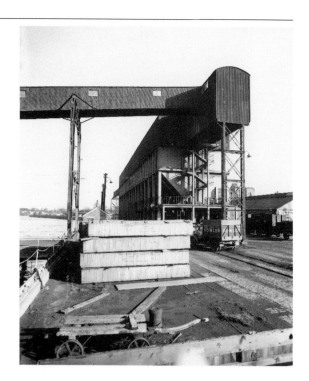

The overhead coal delivery system, from colliery to Gas Factory.

Paper Cartridge Factory, 1956.

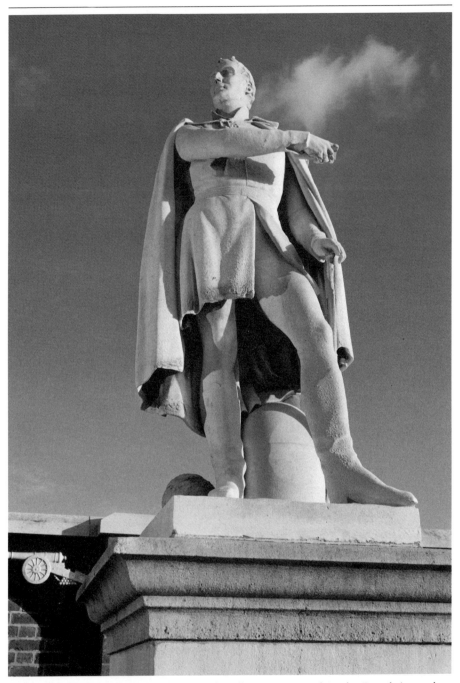

Statue of Arthur Wellesley, 1st Duke of Wellington, erected in the Royal Arsenal to commemorate his term of office as Master General of The Ordnance, 1818–27.

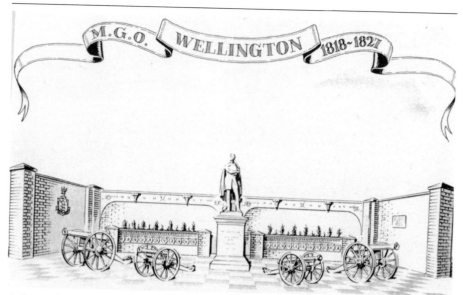

A design for the Wellington Memorial.

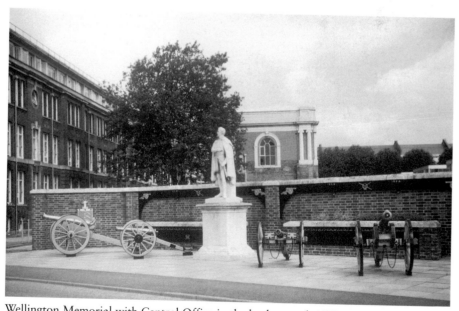

Wellington Memorial with Central Office in the background. (AT)

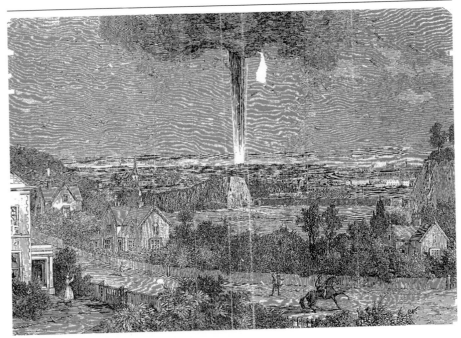

The Powder Magazine explosion of 1864.

Sir Frederick Abel, the first War Department Chemist (1854–88). (RAWHS)

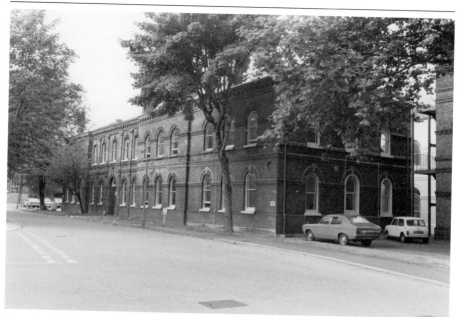

Chemical Laboratory, opened in 1864.

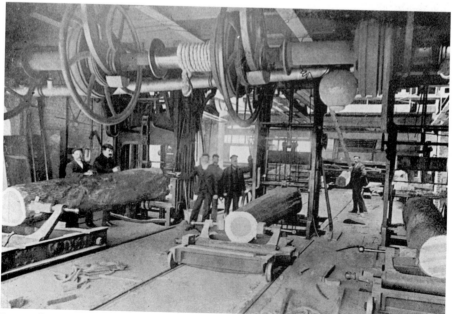

Saw-mills of the Royal Carriage Department. (RAWHS)

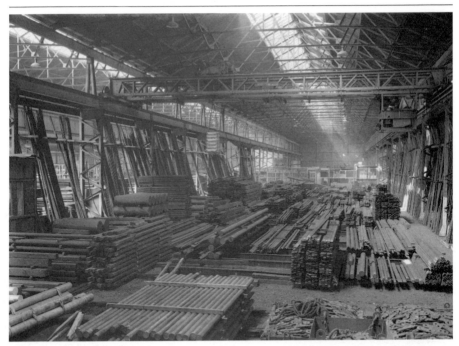

Timber stores.

A loading table for a rifle battery. (RAWHS)

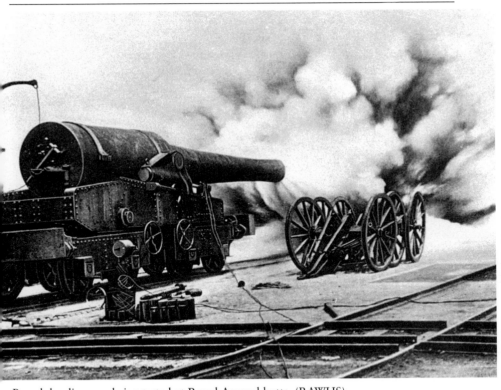

Breech loading gun being tested at Royal Arsenal butts. (RAWHS)

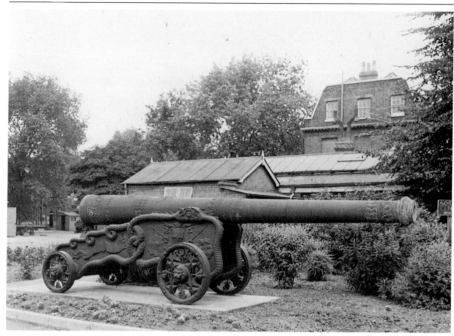

Maltese Gun, with Verbruggen House in the background.

River barge *Magog* moored at the Royal Arsenal. (IWM)

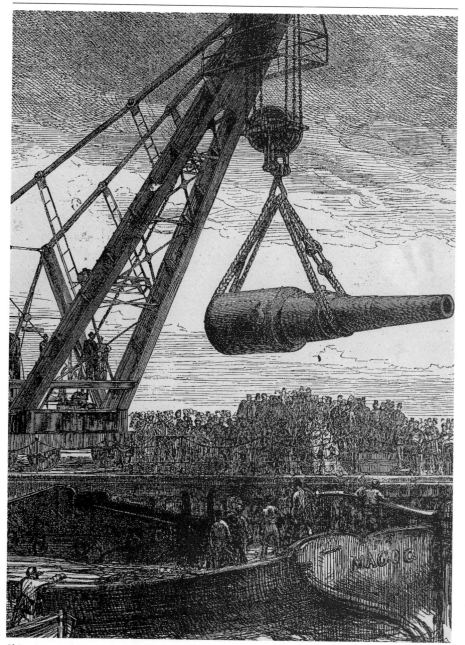

Shipping an 80 ton gun on the *Magog* barge, 1876. (*ILN*)

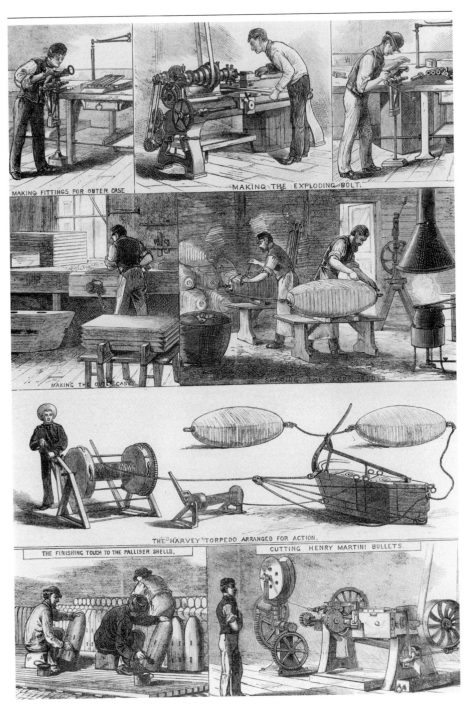

Range of production at the Royal Arsenal.

Torpedo Range on the Ordnance Canal. On the left is the New Army Ordnance Stores and, on the right, the 'Danger Buildings' of the Filling Factories. The 500 yard straight run of the canal was used for torpedo testing until 1908.

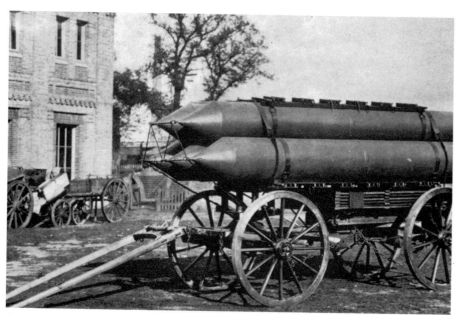

Some early models of experimental torpedoes. (RAWHS)

The gun burst explosion on HMS *Thunderer*. (*The Graphic*)

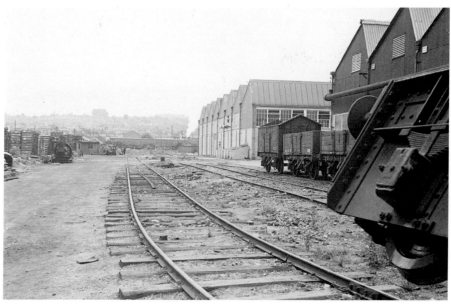

The Royal Arsenal Railway runs through typical 'Danger Building' country.

Marshalling yards at No. 4 Gate, the connection with the national network.

Royal Naval Armament Department gun stores.

Building E79, Cartridge Factory No. 5.

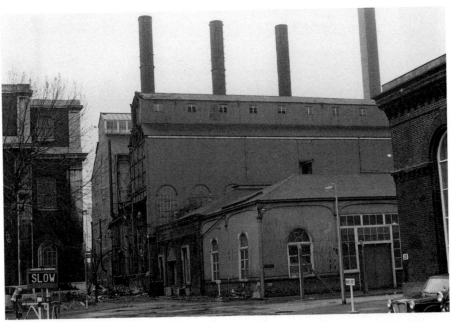

Royal Arsenal Power Station.

Loading gantry on the west side
of the Power Station.

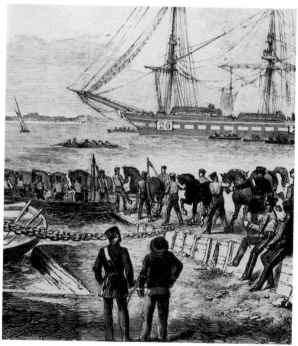

Embarking horses for the
Crimean War from the
eastern wharf. The 'T' Pier
was built because of the
bottleneck in loading at the
riverside. (*ILN*)

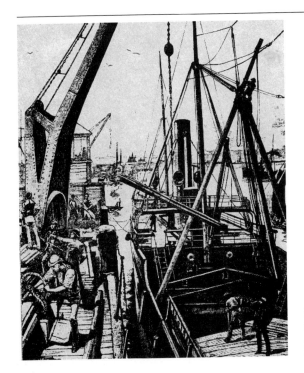

SS *Sir Evelyn Wood* loading stores at the 'T' Pier for the Berber-Suakim railway in the Sudan, 1884. (*ILN*)

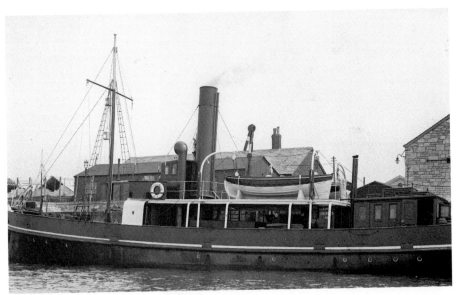

SS *Stewart* in Dover harbour. (NMM)

Section Three
THE TWENTIETH CENTURY

The start of the twentieth century saw the construction of the Central Office, now Building 22 (p. 94). Dated 1908, it was completed in 1911 and became the centre of administration for the whole Arsenal complex. Senior managers had their offices in this building together with Drawing and Pay offices. The photograph shows the south entrance, and also the adjacent Duke of Wellington Memorial. The north entrance is also shown on p. 94.

In 1886 workers in Dial Square had formed the Dial Square Football Club, and by 1891 they were playing a draw with West Bromwich Albion. By that time they had become the Woolwich Arsenal Football Club (p. 95), and in 1903 they played Blackburn Rovers and won! In 1904 the team played a Parisian eleven at the Manor Ground, and won by 26 to 1! In 1913 the club moved to Highbury and became the 'Arsenal'.

Following a report by the Inter-Departmental Committee set up under the chairmanship of Sir G.H. Murray, to consider the operation of Government factories generally, it was decided to amalgamate the Royal Gun Factory and Royal Carriage Department. They were united in 1907 in order to secure greater co-ordination in the work of the two factories. The new establishment was known as the Royal Gun and Carriage Factory. Some idea of the range of weapons produced by the new enterprise is shown on pp. 96–8. The lower picture on p. 98 shows the entrance to the main Erection Shop.

As ordnance grew in size, particularly in the case of large Naval guns, it became necessary to contract out much of the work to civilian firms such as Vickers-Armstrong. In 1909, however, new Shrinking Pits (p. 99) were constructed in the Arsenal in order to increase the capacity for the heat-treatment of guns, this process being required to achieve the maximum strength of the gun. The heat-treatment involves heating the gun barrel to a

white heat and then quickly lowering the barrel into a deep pit of oil to 'quench' or 'harden' the barrel.

The First World War

From 1915 until 1920 the Ministry of Munitions took over the Royal Ordnance Factories from the War Department. During that period the Royal Arsenal grew enormously, from sheer necessity of maintaining the level of production needed to keep up with the requirement for supplies at the front line (p. 100, top picture). Up to 80,000 people were working in the Arsenal at that time, many of them women owing to the absence of men at the front (p. 101). In addition to the Arsenal, there were many other factories all over Britain doing similar work. Some idea of the enormous increase in production achieved during the early war years is shown in the picture on p. 102. A most interesting video-film, *Woolwich Arsenal and Its Workers – 1916*, is available at The Imperial War Museum and shows many of the activities of the Arsenal at that time. A general impression of the western end of the site can be obtained from the photographs on pp. 103–4. Whilst photographs of the Arsenal river-front were not encouraged for reasons of security, the lower photograph on p. 104 was taken during the period 1936–9 and shows, to very good effect, the various features of the riverside piers and buildings as they would have been during the First World War.

The Second World War

During the 1930s the authorities appreciated that in any future war air attacks were very likely to occur, and it was therefore necessary to disperse the Government's armament manufacturing factories. A policy of dispersal was accordingly implemented and new Royal Ordnance Factories were built in such places as Chorley, Blackburn, Glascoed and Dalmuir. The Arsenal remained, however, a very important production centre for munitions although the workforce was much reduced compared with that during the First World War when it reached something over 30,000. The Arsenal was subjected to a considerable number of air attacks during the war, including those by German bombers, V1 pilotless missiles ('flying bombs') and V2 rockets. Over the period of the war 103 persons were killed in such attacks and 770 injured.

Photographs of my father, George Finch Masters OBE, MIMechE, CM, are few and far between but some (pp. 105–6) have survived and show my father with various visiting VIPs, Hore-Belisha (in 1938), His Majesty King George VI with Sir F. Carnegie, Chief Superintendent of Ordnance Factories (in 1939) and His Majesty King George VI with Herbert Morrison (in 1940). Some idea of the tremendous range of weapons that my father was associated with during his long association with the Royal Arsenal is given by the photographs on pp. 107–11. When my father died on 16 November 1962 his death was reported in the National press with a reference to 'Our Armaments Expert'.

The 'Unbelievable Arsenal'

The photograph at the top of p. 112 was taken in the Arsenal in about 1930 and you could be excused for thinking that it was a peaceful part of rural Kent. It is, in fact, Harrow Manor Way on the Erith Marshes running from the Berber Gate to the Berber sea-wall. The photograph was taken from near Berber Gate. Part of the old Police Quarters are just visible on the right, also the Royal Arsenal railway track. In more recent times the Royal Ordnance Factory Sports Association had its ground in this area (p. 112, lower picture).

South entrance to the Central Office.

North entrance to the Central Office: note the 'bridge' in the inner courtyard, an interesting architectural feature. (GFM)

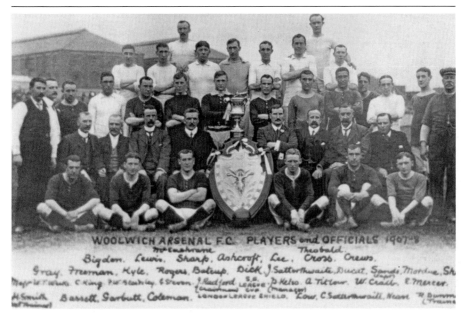

Woolwich Arsenal Football Club, players and officials, 1907–8.

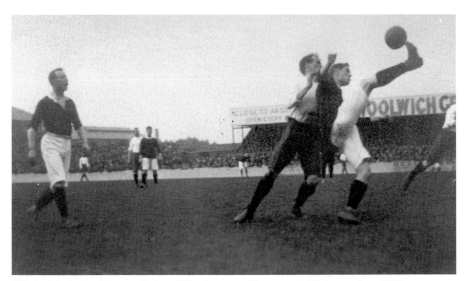

Woolwich Arsenal versus Bolton Wanderers at Plumstead, 30 September 1905.

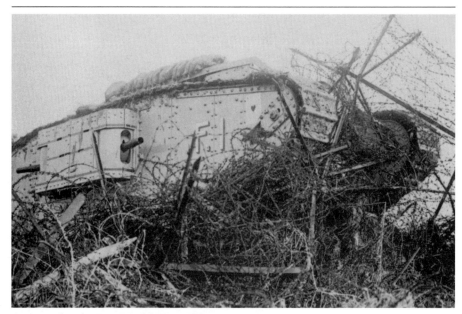

Armoured tank, First World War. (IWM)

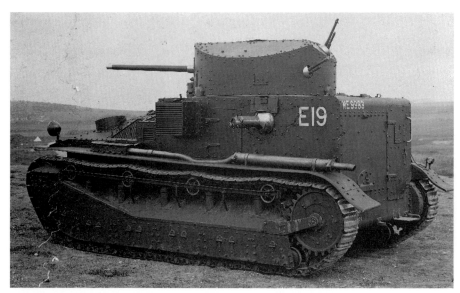

Vicker's Mark II armoured tank on a testing ground, 1930s. (GFM)

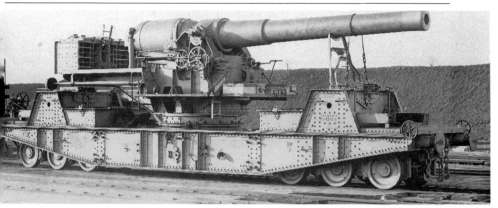

Breech loading, 9.2 inch, Coastal Defence gun, Mark XIII, on Mark IV mounting at Shoeburyness, 1936. (GFM)

Seventeen-pounder anti-tank gun (Panzer Blaster), produced during 1943–5. (GFM)

Fourteen inch Railway Gun, breech loading (1940). (RAWHS)

Building C10, the Main Machine and Erection shops of the Royal Gun and Carriage Factory. This is the north entrance, opposite the Central Office.

Inside the 'Shrinking Pit' at the Royal Arsenal, 1900. (NMM)

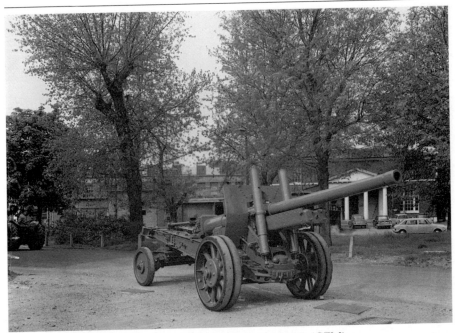

Heavy Howitzer, with solid tyres, ready for dispatch, 1916. (GFM)

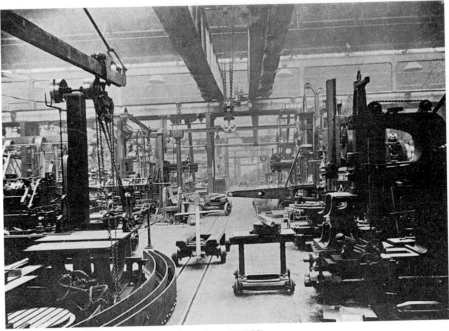

Main Machine Shop from the south end. (RAWHS)

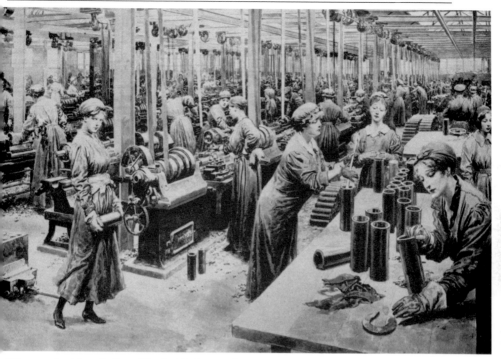

Women checking shells at Woolwich during the First World War.

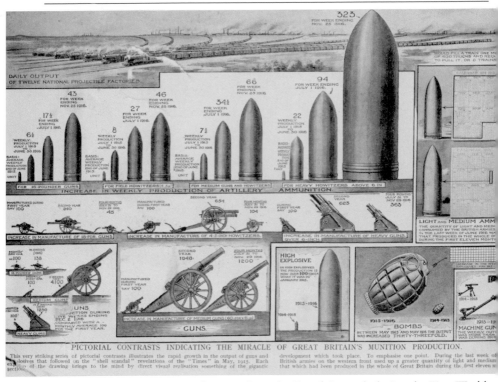

Diagrammatic representation of output from the Royal Arsenal, during the First World War.

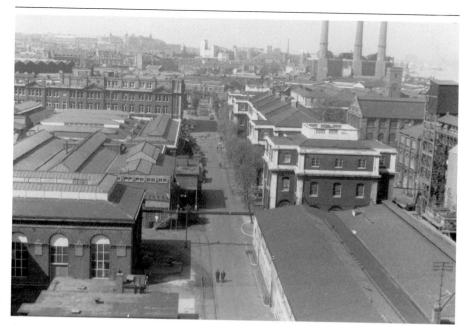

General view of the Royal Arsenal.

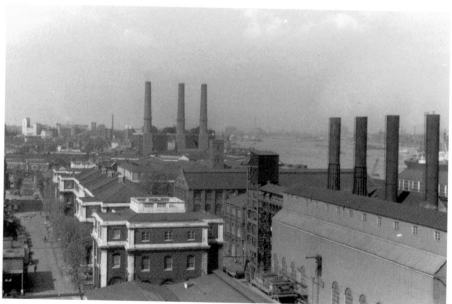

Grand Military Store.

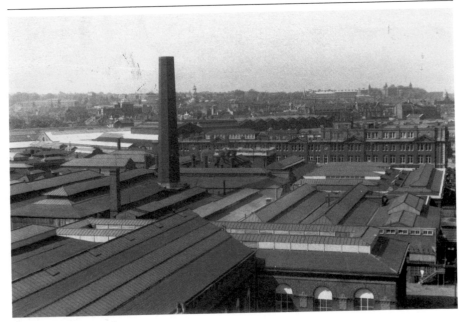

Shell Foundry complex.

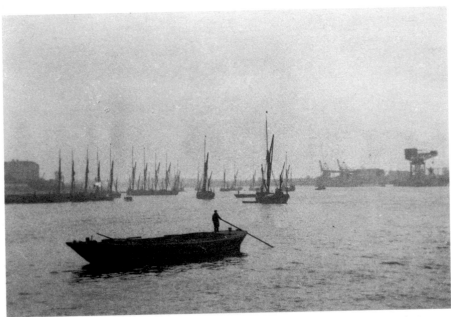

View of the river Thames, the Royal Arsenal river-front and piers. (G.W.C. Taylor)

Visit by Hore-Belisha, 1938.

Visit of His Majesty King George VI, 1939.

Visit by His Majesty King George VI, 1940.

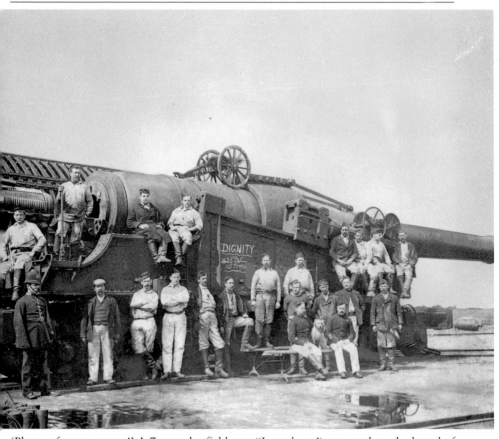

'Plenty of room on top!' A 7 pounder field gun ('Impudence') mounted on the barrel of a 16.25 inch 110 ton breech loading gun ('Dignity') for fortress and coastal defence work. (RAWHS)

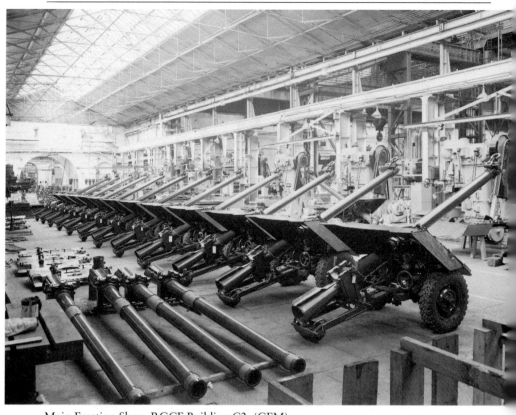

Main Erection Shop, RGCF Building C2. (GFM)

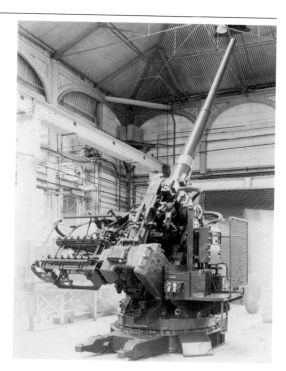

Erection Shop C3, where an automated anti-aircraft gun is almost complete. (GFM)

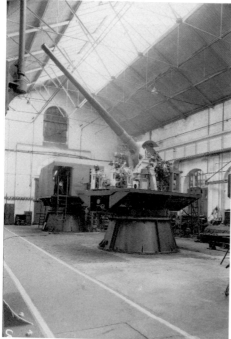

A 9.2 inch Coastal Defence gun awaits the fitting of a shield in C3 Erection Shop. (GFM)

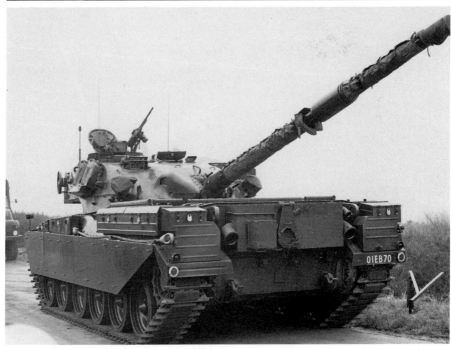

A Crusader tank en route to the tank testing track. (GFM)

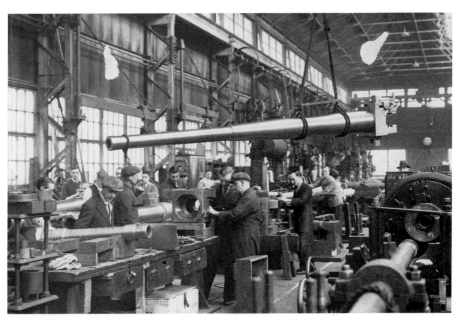

A 9.2 inch Coastal Defence barrel 'coming along nicely'. (IWM)

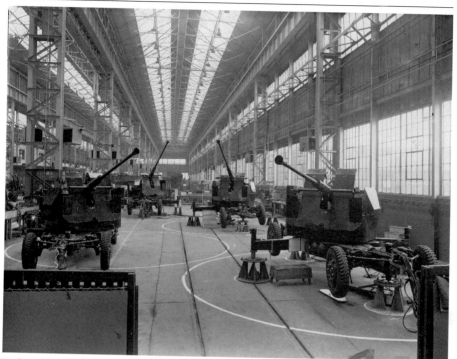

Bofors 40 millimetre anti-aircraft guns, 1940. (GFM)

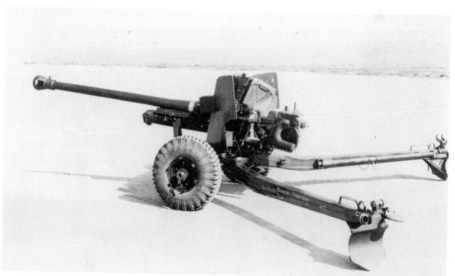

A seventeen-pounder anti-tank gun, as used at El Alamein to defeat the German armour. (GFM)

Harrow Manor Way, 1930s. The Police Quarters are just visible on the right.

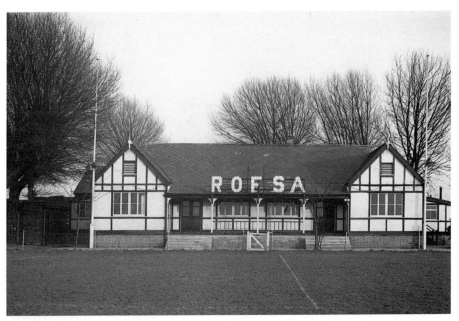

Clubhouse of the Royal Ordnance Factory Sports Association. (RAWHS)

Section Four

THE PRESENT AND THE FUTURE

Following the closure of Royal Ordnance Factory (Woolwich) in 1967 and the building of the new town, Thamesmead, the part of the Royal Arsenal site occupied by the Ministry of Defence rapidly shrunk from its 1,300 acres to the present 76 acres. In recent years the site has been occupied by the Director General of Defence Quality Assurance who was responsible for maintaining the quality of defence equipment supplied to the Armed Forces. Following the decision to close the site, the Ministry of Defence finally departed at the end of December 1994, and the site is now awaiting redevelopment.

Whilst many of the interesting factory buildings were pulled down after closure of the ROF, there are, fortunately, many which still remain, including eighteen listed buildings, to remind us of the splendid architecture of the past. Some of these existing buildings are shown in the following photographs which were taken just before closure of the site (pp. 114–25).

When it was announced in 1989 that the MOD were to leave the Royal Arsenal, a number of kindred spirits joined forces to form the Royal Arsenal Museum Advisory Group (RAMAG). The Group proposed the establishment of museums set in a heritage area of the site stretching from Dial Square down to the river. The plans included the creation of a Heritage Centre, incorporating the historic buildings such as the Royal Brass Foundry, in which would be re-created, in tableaux and audiovisual form, the casting processes that were employed to manufacture brass cannon in the eighteenth century. Whilst much work remains to be done, RAMAG has presented the proposals to the Greenwich Borough Council, and it is encouraging that these are very much in line with the Councils' Waterfront Strategy which aims to harness private and public sector money to provide jobs, homes and leisure opportunities along the 7-mile waterfront between Thamesmead and Deptford. More recently, the Royal Artillery Institution has considered transferring the Rotunda and Regimental Museums, at present situated on

Woolwich Common, to the Royal Arsenal, and this is currently awaiting a final decision. Approval has also been given by Greenwich Borough Council to move the Borough Museum into the Royal Arsenal site, probably in the Dial Square area. Other organizations, such as the British Library, are also considering occupying part of the site.

Whilst the present site covers a mere 76 acres, we are hopeful that the important role played by the Royal Arsenal in the history of our Nation will one day be explained to visitors in a Heritage Centre worthy of the many thousands of workers who have passed through its gates.

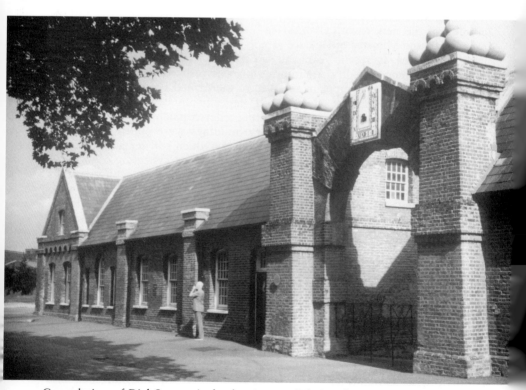

General view of Dial Square Arch, showing sundial, Storehouse and Workshops. The photograph includes the author, Roy Masters. (AT)

DIAL SQUARE ARCH
1717

Attributed to Sir JOHN VANBRUGH.
The only surviving part of "The
Great Pile of Buildings". Guns cast
in the Royal Brass Foundry were bored
and machined here. The sundial dates
from 1764. Arsenal Football Club
(formerly Dial Square F.C.)
had its origins here.

Plaque on Dial
Square Arch. (AT)

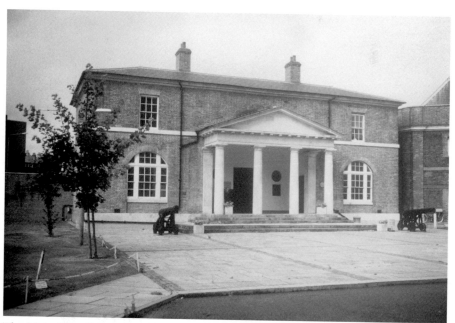

The Main Guardhouse, used latterly as the pedestrian entrance from Beresford Square.
(AT)

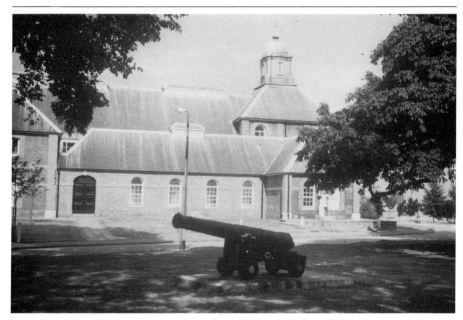

General view across Dial Square showing the Royal Brass Foundry. (AT)

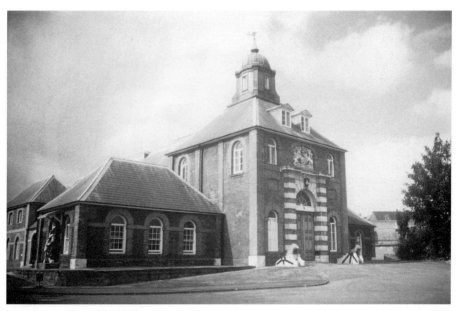

Royal Brass Foundry. (AT)

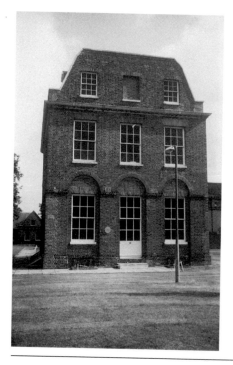

VERBRUGGEN'S HOUSE
1773
Built for
IAN & PIETER VERBRUGGEN,
Joint Master Founders at the
Royal Brass Foundry. Subsequently
used by the Ordnance Board under
various titles until 1939

Plaque on
Verbruggen's House
(1773). (AT)

Verbruggen's House. (AT)

View north from Dial Square towards the river, showing East Royal Laboratory Pavilion on the left. (AT)

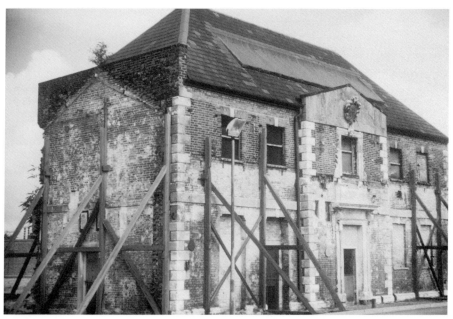

Royal Laboratory West Pavilion, showing William III's crest. (AT)

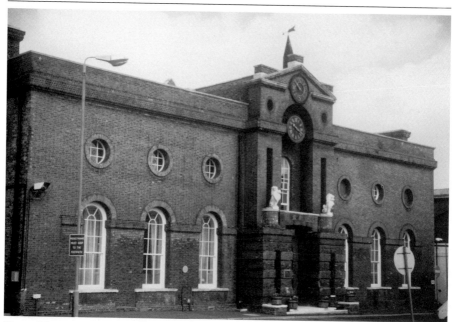

Tower Place or, more recently, the Officers' Mess. (AT)

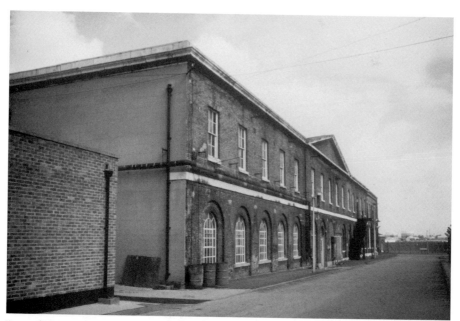

Part of New Laboratory Square. This building is the intended location of the new Royal Artillery museum. (AT)

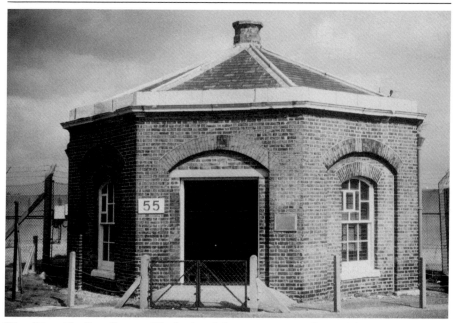

West Riverside Guardhouse. The body of the Prince Imperial rested here before burial; the brass plaque commemorates the event. (AT)

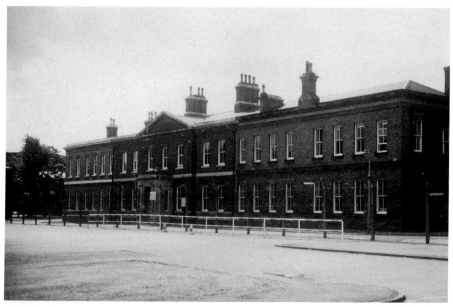

Building 18, the Royal Laboratory Offices. (AT)

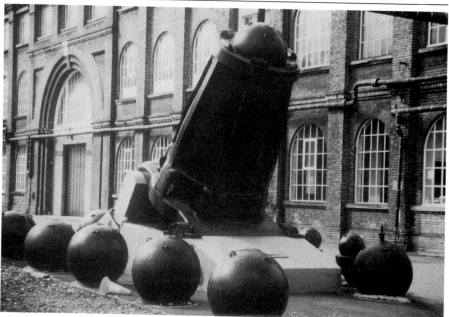

Mallet's Mortar. (AT)

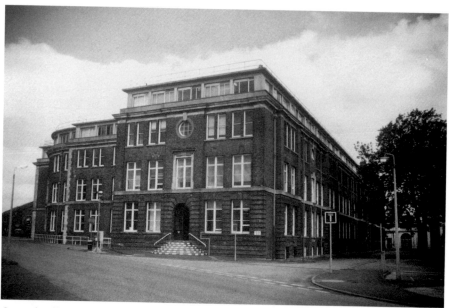

Central Office – main administration centre of the Royal Arsenal. (AT)

Shell Foundry Gates. (AT)

SHELL FOUNDRY GATES

Cast for the Shell Foundry
at the Regents Canal Iron Works in 1856.
Removed and Re-erected at ROF Patricroft
in 1968 on the closure of ROF Woolwich.
Returned by Royal Ordnance to
the Royal Arsenal Woolwich
and Recommissioned 31 May 1991
by Sir Sidney Bacon CB,
Controller and Managing Director
Royal Ordnance Factories 1969-1979

Plaque commemorating the return of the Shell Foundry Gates. AT)

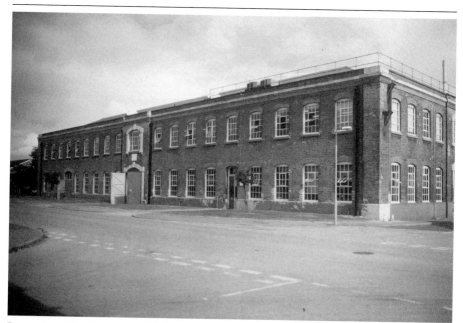

Paper Cartridge Factory and ROF(W) Metallurgical Laboratory. (AT)

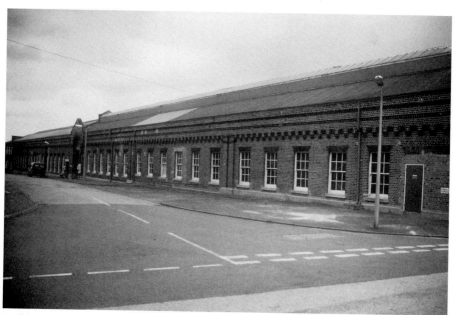

Building C58 – Royal Gun and Carriage Factory. (AT)

Part of the original Royal Arsenal wall with Middle Gate House in the background. (AT)

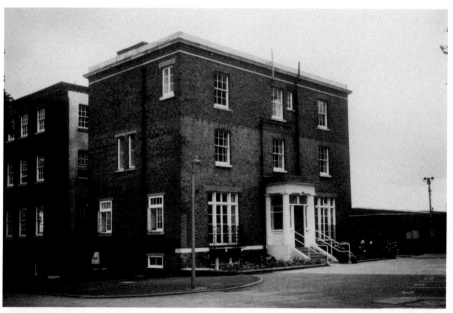

Middle Gate House. (AT)

View from the Royal Arsenal river front, looking west towards Woolwich Ferry and the Thames Barrier. (AT)

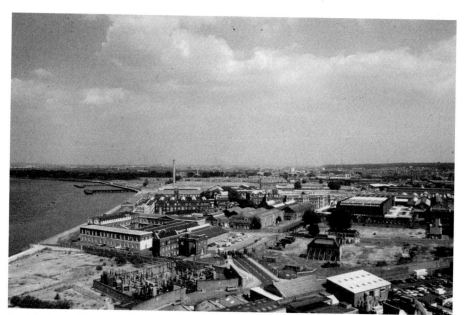

Aerial view of Royal Arsenal West, 1993. (RAWHS)

Acknowledgements

My gratitude is freely and gratefully expressed to the many organisations and individuals who gave up their time and services in helping me to prepare this publication. In particular, it must be stressed that this might never have been possible without the active support and co-operation of the Royal Arsenal Woolwich Historical Society and Mrs J. Tomkins of Eltham.

For some photographs of the time I lived in the Royal Arsenal I am indebted to other residents and neighbours, particularly Roy and Bridget Abbott, G. Taylor, Mrs E. Fisher and the Masters' family archives. Credit for the various photographs, illustrations and other historical material used in this publication is given to the following:

The Royal Arsenal Woolwich Historical Society (RAWHS)
The *Illustrated London News* (*ILN*) • The Imperial War Museum (IWM)
The National Maritime Museum (NMM) • The National Army Museum
The British Museum • The Greenwich, Woolwich and Plumstead Libraries and Museum Facilities • Official Records of the Ministry of Defence
The Royal Artillery Association, Library and Museums
The Royal School of Military Engineering, Chatham
The Military College of Science, Shrivenham • Thamesmead Town
The Graphic Magazine • *The Royal Arsenal: Its Background, Origin & Subsequent History* by Brigadier O.F.G. Hogg • *The Royal Arsenal Woolwich* – the 'Red Book' by Wesley Harry, published by the Ministry of Defence
The Floating Prisons of Woolwich and Deptford by R. Rigden
Woolwich by Darrel Spurgeon • *The Royal Arsenal Railways* by N.W.J. Gibson
The 18 inch Royal Arsenal Railway; *Woolwich* by B.R. Clarke & C.C. Veitch
London's Arsenal by Charles Job • *Arsenal Guide* by H. Knell
Chemical Service in Defence of The Realm by W.G. Norris
The Building Engineer • G.F. Masters (GFM) • W. Steven Dews • S. & N. Buck
I.G. Hampson, Project Engineer (Rtd) at Thamesmead Town
Ms B. Gillow, Curator Greenwich Borough Museum • Paul Sandby, Artist
G.W.C. Taylor • Jack Vaughan, Woolwich Antiquarian Society • W.J. Genese
W.L. Wylie, Royal Artillery • W.T. Vincent, various publications on the history of Woolwich • P.M.E. Erwood • Julian Watson, Greenwich Borough Local History Centre • Harry Baker, who worked for forty-six years in the Royal Arsenal • Mrs E. Fisher

Finally, many thanks are due to Alan Turner (AT) of the Royal Arsenal Woolwich Historical Society and to the photographic facilities of Percival's Camera Centre of Eltham who performed miracles with some very old material.

BRITAIN IN OLD PHOTOGRAPHS

To order any of these titles please telephone Littlehampton Book Services on 01903 721596